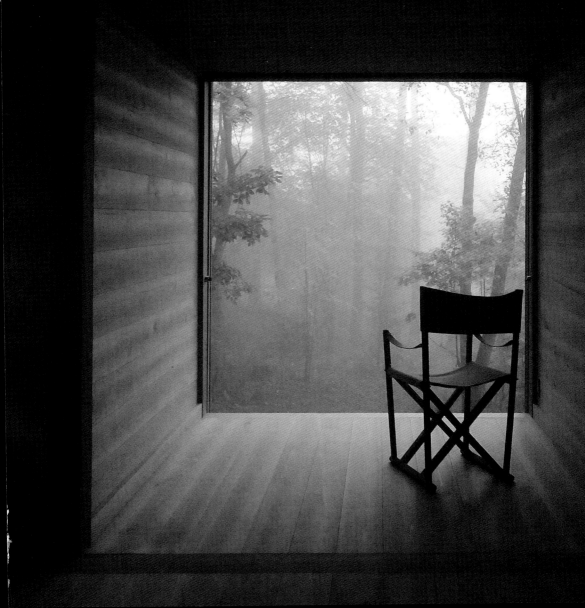

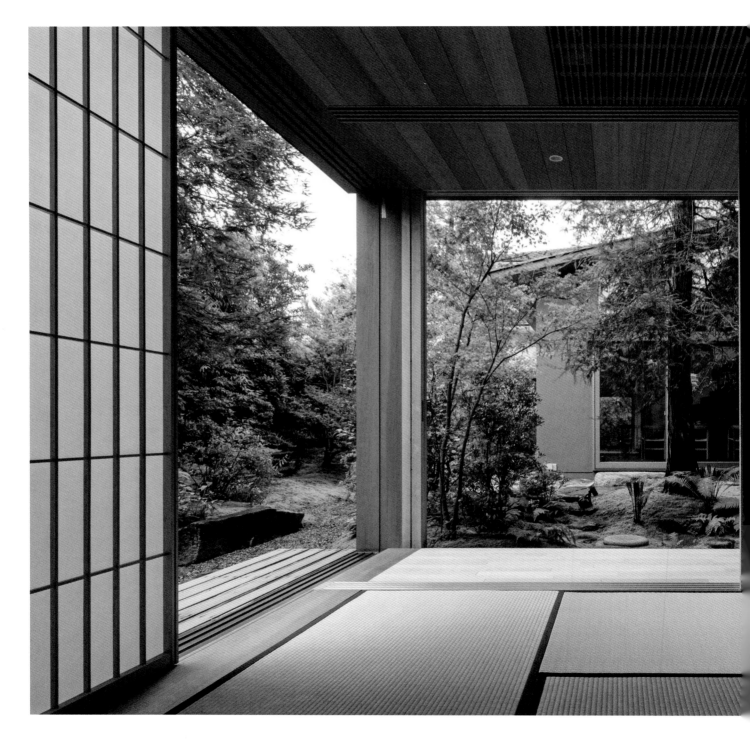

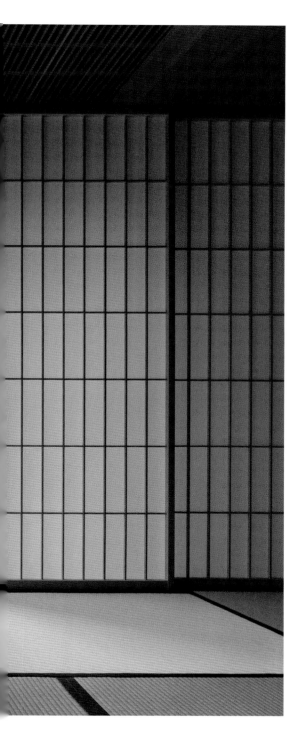

ECO LIVING JAPAN

Sustainable Ideas for Living Green

Deanna MacDonald
Foreword by Edward Suzuki
Preface by Geeta Mehta

TUTTLE Publishing

Tokyo | Rutland, Vermont | Singapore

CONTENTS

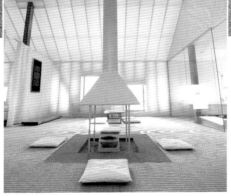

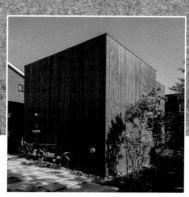

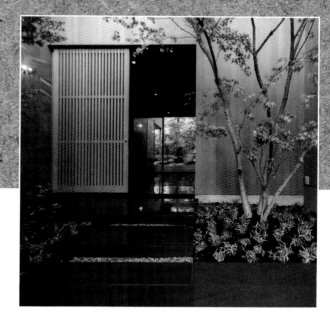

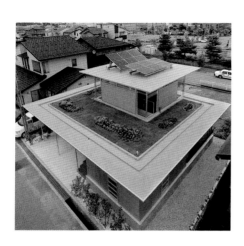

Foreword

In the old days, the Japanese wisely employed the concept of *shakkei*, meaning 'borrowed scenery', to enlarge and enrich their rather small piece of property by taking in the neighboring vista as part of their own. Unfortunately, this practice is fast disappearing in dense urban environments where many seek privacy rather than connection. As a result, I have been often asked to design defensively. Over time, I have developed a pattern of design I call 'Interface', whereby a strong demarcation, such as a fence or a screen, is made at the site boundary. Behind this screen is a cushion of green, usually bamboo. This combination of screen and green is Interface, an intermediate space between inside and out. Looking back at my experiences, I realize that what I had cultivated was not wholly new but had its roots in traditional Japanese architecture.

Engawa, the corridor running around the periphery of a house, is central to traditional Japanese design. It is neither outside nor inside but is simply an interface between two worlds. To my happy surprise, I discovered that what I had come up with was nothing more than a modernized version of the traditional *engawa*. I began to realize, moreover, that there was a wealth of other design vocabulary from the past that I could learn from and apply in modern design. If we could only capture the wisdom of traditional Japanese daily living and translate that into our contemporary lifestyle, then there would be so much that could be accomplished using new materials, technology and design!

Since this realization, my private practice, Edward Suzuki Associates, has been applying this centuries-old traditional Japanese architectural know-how, particularly in our house designs. Since 1945, Japan has, unfortunately, abandoned these traditions, losing the qualities inherent in the old ways, to embrace Modernism. As such, at my practice we are now relearning and reapplying the principles that once made Japanese architecture

so successful. Such a procedure, however, is not unique to my office, but is becoming increasingly prevalent generally.

The following are examples of traditional wisdom from which we try to borrow to achieve sustainable, healthy and comfortable homes: *Engawa*, as mentioned, is the peripheral corridor that runs around a traditional Japanese house. It is the intermediate space. In the summer, sliding partitions are removed to allow cross-ventilation and connect inside and out. In the winter, storm doors and *shoji* screens are returned to increase thermal insulation and minimize heat loss. *Tsukimidai* is a moon-gazing terrace, an interface between heaven and earth, a nostalgic planetarium and a form of borrowed scenery on a grand scale. *Tsuboniwa* is a pocket garden and interface between inside and outside. Some are as small as a square meter, but nonetheless can do wonders, allowing in natural sunlight and breezes while pleasing the soul. *Tokonoma* is a stage in a tearoom, usually one *tatami* in size, where seasonal art, such as a floral arrangement, is displayed, thus bringing the outside in. *Irori* is a hearth where not only food but, more importantly, bodies and souls are warmed. *Hisashi*, or deep eaves, allow winter sun to penetrate but prevent the scorching sun and rain from entering the interior. *Shoji* and *kohshi*, louver screens of wood, bamboo or reeds, soften harsh natural sunlight to diffuse gently inside. *Tsuufuu*, or natural cross-ventilation, carries gentle breezes throughout the house by means of windows and doors to minimize use of air-conditioning and energy. *Uchimizu* is literately 'scattering water' in front of and around a house to tame summer heat.

While Japan prides itself today in its development of futuristic high-tech innovations, it also has a vast, environmentally wisdom-rich inheritance from which future generations can benefit and prosper.

Edward Suzuki

Preface

Given its history of architectural and product design using natural, reusable materials, its powerful aesthetics and cutting-edge technology, the world looks to Japan for inspiration and leadership in the field of sustainable design.

But what is sustainability? Is a building full of energy-saving features worthy of sustainability certification if it is built by tearing down another potentially usable building, is grossly oversized or is built far from where its users live or work? This question needs to inform a holistic dialogue about sustainable architecture, which must exist within the framework of sustainable neighborhoods and cities. Japan does less well on this count. There is no reason for a typical Japanese house to be rebuilt every 30–40 years, or much sooner if the builder can persuade the owner that new earthquake-related laws or chipped paint is reason enough to tear down the old house and make a new one. Just as Japanese architects are questioning every aspect of unsustainable practices in architecture, Japanese consumers must also ask questions about rebuilding their still usable and repairable homes. After all, Japan has the world's oldest extant wooden building, the temple of Horyuji built more than 600 years ago.

Sustainable buildings are just one fix to the spectrum of unsustainable lifestyles we have created over the past few decades of global prosperity and hyper-consumptive behavior. A few sustainable buildings cannot alone change the indicators of pollution, climate change and depletion of non-renewable recourses. The urban form must also be sustainable, with mixed-use development that aids healthy and sustainable lifestyles that are less dependent on private cars for transportation. Japanese cities are already high density, and therefore more efficient than most world cities, but urban sprawl and depletion of Japan's precious forest and farm lands must also continuously be checked.

Sustainable building design should also include physical and social dimensions. The built environment has the power to enhance or deplete the social capital and social equity of cities, and policy directions must ensure that Japan's social capital, one of its main assets today, is nurtured and sustained through every urban intervention. This includes resisting the building of big box stores, shopping malls and gated communities at the expense of vibrant neighborhoods and shopping streets.

Sustainability has to do not just with the moment a building is built but also its life-cycle costing. This includes non-renewable materials used in its construction, the distance these materials travel to arrive at the site, energy use in construction, operational efficiency, maintenance and final destruction. Destruction of buildings is following the way of cars, ipads and clothing, where obsolesces are built into things to keep the makers in business.

This book focuses on exceptional work by architects who have gone much further than required under the Comprehensive Assessment System for Built Environment Efficiency guidelines developed since 2001. These guidelines are grossly inadequate at present, often more of advertising gimmicks than real attempts at addressing the most pressing issues about sustainability. However, they are a good start, and it is hoped that they will evolve into more meaningful guidelines and regulations over time.

This book focuses on exceptional work by architects who have gone much further than required under the CASBEE (Comprehensive Assessment System for Built Environment Efficiency) guidelines developed since 2001. The easy-to-understand format, succinct text, sidebars that call attention to specific technologies and methodologies, and photographs to illustrate the concepts will enable an expert as well as a caring citizen to enjoy the book while learning about important new directions in the field of sustainable architecture.

Geeta Mehta

THE SUSTAINABLE JAPANESE HOUSE: PAST, PRESENT AND FUTURE

Deanna MacDonald

"I do not know the meaning of 'Green Architect.' I have no interest in 'Green,' 'Eco,' and 'Environmentally Friendly.' I just hate wasting things."
Shigeru Ban, 2014 Pritzker Prize laureate

Today, everything from coffee to skyscrapers comes with claims of sustainability, often complete with a 'green' label. The line between marketing strategy and truly sustainable design has diluted the concept of green building to the point where architects like Shigeru Ban, known for context-sensitive humanitarian design, distance themselves from labels seen as meaningless.

Sustainability starts not with a marketing department but in the first stages of design and follows through resourcing and production into use and eventual reuse. This should be Architecture 101 worldwide. Yet, truly sustainable architectural design is rare. This makes the projects in this book all the more remarkable. These houses embody Japan's recent move towards (or perhaps back to) a sustainable living environment, albeit with cutting-edge technology. These are designs that work in harmony with their environment and the people who use them.

Shigeru Ban's words echo the concept of *mottainai*, a Japanese term expressing regret for wasting an object or resource. Loosely translated as 'waste not, want not', it is at the heart of traditional Japanese building. Traditional Japanese architecture, based on the 100 percent recyclable building materials of wood, paper and *tatami*, has always prized and worked in response to nature. This tradition was subsumed in Japan's modern evolution into one of the densest urban centers in the world. It never wholly disappeared.

This book is about one of the most fundamental choices about how we live—our homes. Much of the world is now concerned with issues of sustainability, the environment and climate change. We all want to live in comfort and beauty. But is it possible to create a house that has beauty, functionality *and* sustainability? Can it be made affordable? This book offers an introduction to the unique ways Japanese design is responding to these concerns.

Pitched thatch roofs of traditional *minka* farmhouses.

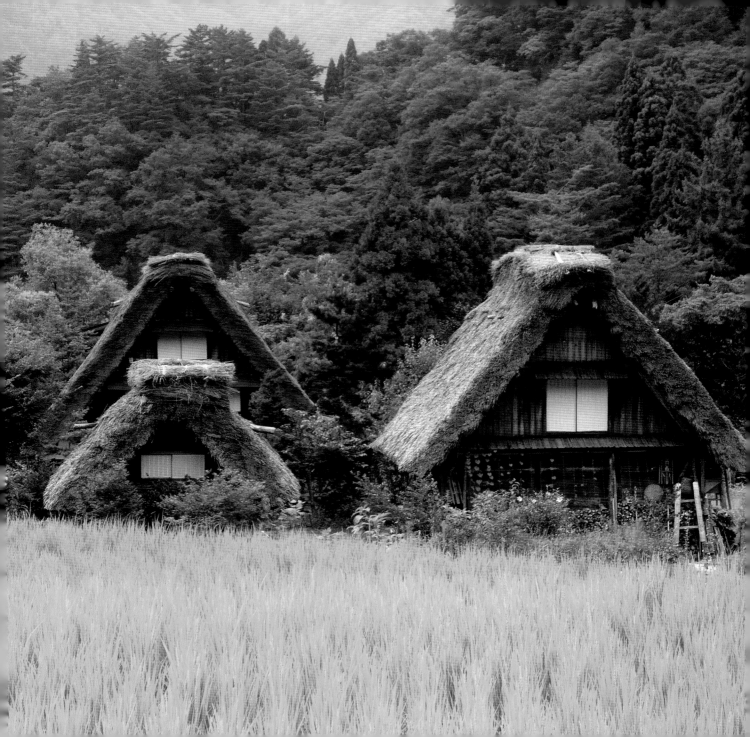

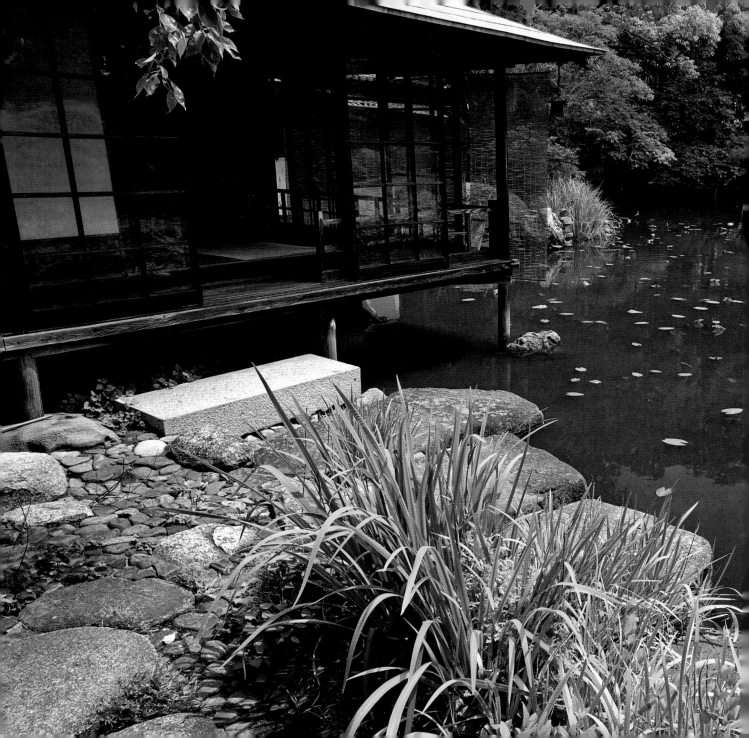

The Past

The elements of the Japanese house can be traced back to the aristocratic Shinden-style residences of the Heian era (794–1192), which were wooden post-and-lintel structures set on pillars, topped with pitched roofs and surrounded by gardens. The concept of the house evolved around the thirteenth century with the arrival of Zen Buddhism with its ethos of 'eliminating the inessential'. A building was not just protection from the elements but an expression of the human relation to nature, with materials as unadorned and ephemeral as the world around it. Beauty and simplicity were one.

While both Shinden architecture and Zen philosophy originate in China, together they evolved into a new, distinctly Japanese aesthetic that resonates through Japanese architectural history. From the Muromachi period (1336–1572), various types of houses developed. There was the sturdy rural farmhouse, or *minka*, and the urban merchant house, or *machiya*. Aristocratic and samurai homes were built in the formal *shion* style, an evolution of the earlier Shinden style. As the tea ceremony grew in popularity, the ideal of the humble teahouse strongly influenced house design. The more relaxed Sukiya style, epitomized by the early Edo-era (1615–1868) Katsura Imperial Villa in Kyoto (see pages 136–7), found beauty in imperfection and ephemerality. The beauty of *wabi sabi*, once translated by Frank Lloyd Wright as "rusticity and simplicity that borders on loneliness", was considered the height of sophistication. Sukiya interiors favored the unpredictability of asymmetrical modular layouts and varied materials and textures but linked all into a cohesive whole with strong lines and a muted color palette. And in all, attention to detail and craftsmanship were paramount.

These traditional Japanese houses were built from the inside out with the exterior reflecting the inner workings of the modular plan. As the European house gained a strong attachment to order and ornament, Japanese houses developed as simple flexible spaces with multiple uses and a 'lightness' that reflected the realities of living in an area of frequent earthquakes and Buddhist teachings of the transience of all things.

This functional approach resonated with early twentieth-century Modernists such as German architect Bruno Taut, who on visiting the seventeenth-century Katsura Imperial Villa in 1933 declared, "Japanese architecture has always been modern." For Taut, trained in the Bauhaus with its mantras of 'form follows function' and 'less is more', Japanese architecture was a revelation: "The form and shape are not so important; the relationship with the environment is a more singular factor."

This structural modularity came to be based on the size of an average *tatami* mat (generally 90 x 180 cm, though there are local variations), considered the correct size for one person to sleep on. The size of a traditional room is measured by its number of *tatami*, for example, a six-mat room. Today, the floor area of modern houses is measured in *tsubo*, roughly the equivalent of two *tatami* mats. It was about the same time that Leonardo da Vinci was developing his system of human body-based proportion that the *tatami* mat and, by extension, the human body, became the standard for proportion and scale in the Japanese house.

This human spatial scale is part of Japanese architecture's close relation to the landscape and nature. Often the best part of a property was reserved for gardens and the house built on the remainder. The house design offered a flexibility of space and

The interaction of landscape and building in traditional Japanese architecture.

function that allowed for a fluid relation to nature. Inside, *fusuma* (solid sliding doors) and *shoji* (translucent sliding doors) create layers of spaces that could be opened and closed at will. In fine weather, entire walls could be pushed aside, opening the house to the garden. Twentieth-century architect Antonin Raymond, who spent most of his career in Japan, wrote: "The Japanese house is surprisingly free … one opens up all the storm doors, the sliding screens and sliding doors and the house becomes as free as a tent through which air gently passes."

The garden became part of the experience of the house, the very basis of the concept of *shakkei*, or 'borrowed landscape'. An *engawa* corridor created an intermediary space between inside and out. On summer days, it is part of the exterior experience but in winter and at night, with doors closed, it becomes part of the interior.

Wood is the traditional building material and generations of craftsmen learned to draw out the intrinsic beauty of the material. Art historian Yukio Lippit suggests that Japan's architectural history is closely related to its ecological history. Builders knew their forests intimately and what wood was appropriate for each task, be it structural support in a large temple or expressing the ideals of *wabi sabi* in the materiality of a teahouse. It is worth noting that the high point of Japanese sculpture is considered to be the medieval wooden sculpture of the Kei School, many of whose members were also builders.

And importantly, the traditional house, made of natural materials such as wood, mud, straw and paper, was 100 percent biodegradable and recyclable. Most items were reused and reshaped over time and everything, from the structural materials to *tatami* mats and *shoji* screens, would eventually become compost or fuel.

Architectural historian Azby Brown has studied the development in pre-industrial Edo Japan of multifaceted sustainable systems in everything from agriculture to house building. After a period of deforestation led to building timber shortages and erosion from clear-cutting in the early 1600s, deforestation was halted, agricultural practices were improved and conservationist policies implemented at all levels of society. Daily life was premised on a concept of 'just enough'; nothing was wasted. Brown notes that Edo Japan's practices presage most of the basic tenets of modern sustainable design principles: connecting design and the environment, considering the social and spiritual aspects of design, taking responsibility for the design effects throughout the entire life cycle, ensuring long-term value, eliminating waste, using natural/passive energy flows and using nature as a model for design.

This all began to change with the advent of industrialization in the Meiji era (1868–1914), which also marked the introduction of Western architecture in Japan. Government and public buildings began to be built in Western styles, though the home remained fairly traditional until 1945. Some early twentieth-century experimentation by architects such as Sutemi Horiguchi and Antonin Raymond created a few exceptional homes mingling traditional architecture with early Modernism, but at the end of the war few were interested in the forms of the past.

Cities were rebuilt quickly and apartment blocks rose. The goal was rapid, modern redevelopment. Even the traditional houses of historic Kyoto, spared from the bombs of the war, were mostly destroyed by shortsighted redevelopment that began with Kyoto Tower, part of controversial modernization leading up to the 1964 Olympics. Today, it remains a jarring site on the city skyline though

The play of light and shadow in Yasushi Horibie's House in Tateshina (page 64).

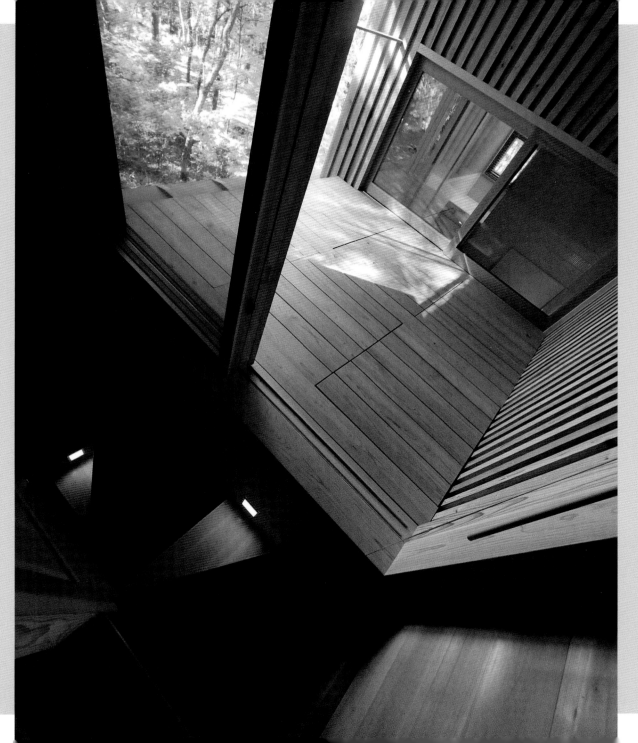

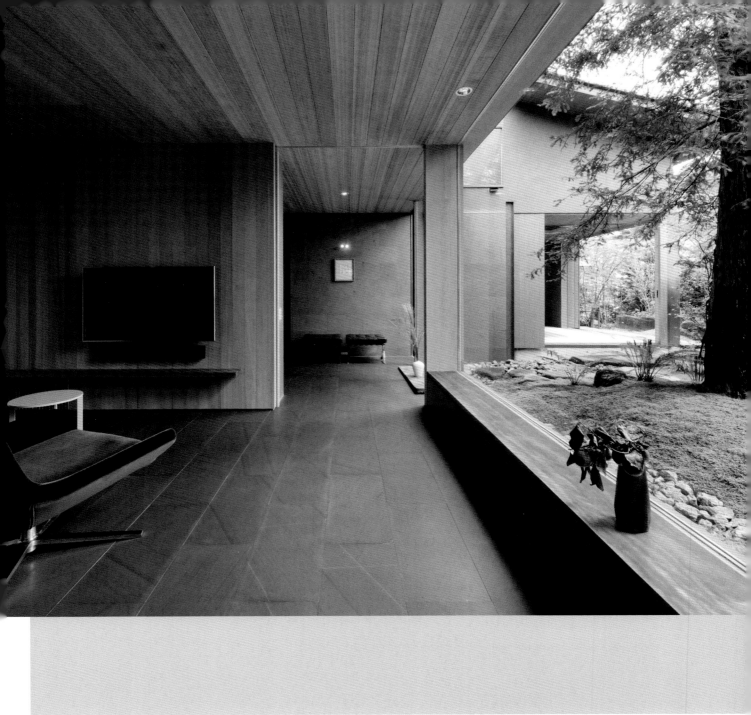

it has been overtaken by ever-rising nondescript towers and the mammoth, controversial Kyoto Station, arguably the most unnecessary building in Japan, emblematic of the loss of the traditional built environment in the later twentieth century. That Japan, so famed for its architecture in tune with nature and beauty, should have completely turned away from its building traditions for cities of concrete and steel still surprises first-time visitors.

The Present

A common adage is that Japan is a country of contradictions. Contemporary Japanese cities are a tangle of skyscrapers, characterless mid-rises, wires and raised highways, and yet they still manage to charm. There is enormous waste but intense recycling. There is a great love of nature but an even greater desire to control it. Tradition is celebrated but newness is highly prized.

House building in Japan today is also full of contradictions. Japan has more architects per capita than any other country, about 3.8 times the number of architects than the USA. There is also a huge demand for new homes in Japan. This is surprising when one considers that the population is shrinking and expected to decrease by 30 percent by 2060, and that today about 17 percent of Japanese homes are left vacant; 2015 estimates suggest there are at least 8 million *akiya* (empty houses) in Japan. Half of all houses are demolished before 38 years (compared to 100 years in the USA). This is closely linked to the fact that houses lose 100 percent of their value after about 30 years, condos after 40 years, because insurance companies will not insure older homes. Some studies put the full loss of value as low as 15 years. It is thus not surprising that contemporary Japanese homes have been called 'disposable'.

Land costs play a large factor. Cass Gilbert, architect of the 1913 Woolsworth building in New York, called the skyscraper "a machine for making the land pay". This is a lesson Japan has learned well. When a home is sold, it is really the land that purchasers are buying. Usually the house is demolished, even if renovations cost less than a new home. And often more profitable multistoried apartment blocks rise in place of the destroyed single-family home, assuming the plot is large enough.

As land prices are exorbitant, most landowners have small, irregular plots. Constantly divided and subdivided as it is sold or divided among each generation, every centimeter of land is valuable, and it is not uncommon to have plots only a few meters wide or in polygonal shapes. Local building regulations are often fairly permissive. Each individual plot is considered as an entity, not as a part of a neighborhood. So clients, knowing the house will not hold long-term value or pass to the next generation, build to their tastes. In these distinct circumstances, architects are often encouraged to create something unique. Houses can take on fantastic forms and whether practical, livable, sustainable or not, often feature in the pages of design and architecture publications worldwide. They can be beautiful, whimsical or daring, yet despite the effort and costs involved, even high-end design houses are rarely built to last. Most owners put in little to no maintenance once their house is built. Why invest in a structure that can only lose value? Thus, even in sought-after neighborhoods, houses are frequently left to rot.

How did this *tatekae* (scrap-and-build) culture come about? On the philosophical side, scholars will point to a love of the new as embodied in Japan's principal Shinto shrine, the Ise Jingu, which has been rebuilt every 20 years since the seventh century. Its

The play of texture and surfaces in the House in Nara by Uemachi Laboratory (page 42).

architectural renewal remains a potent symbol of spiritual purity. The Buddhist belief of the transience of all things is also cited as a rationale.

More concretely, historians point to the aftermath of the Second World War. One million people were homeless and structures were quickly and shoddily rebuilt. By the 1960s, as Japan began to recover economically, these structures were torn down and replaced, in a cycle some say continues today.

Geography also plays a part. Japan's frequent earthquakes contribute to the sense of impermanence related to housing as traditional wooden buildings were often destroyed by a quake or in post-quake fires. The steady advance of seismic technology has led to shifting building codes. Since the Great Kanto Quake in 1923, building codes have been revamped after every major earthquake: in 1950, 1971, 1981, 1987 and, most recently, 2011.

However, most homes demolished today do meet the latest standards. Nevertheless, building companies, particularly since 2011, advertise their high seismic standards and encourage the demolition of older 'dangerous' houses in favor of new 'safe' ones. Some call this 'fear selling', and not necessarily based on structural safety. The highly profitable construction industry in Japan has evolved on the basis of this scrap-and-build system. Just how, and if, this system can be changed remains to be seen.

And, of course, construction comes at an environmental cost. Building in the developed world produces over 40 percent of carbon emissions worldwide and 40 percent of energy consumption. About 50 percent of raw material goes into building, and waste from the construction industry is adding to an already overburdened disposable and recycling systems.

The economist Richard Coup has called Japan's scrap-and-build housing industry an "obstacle to affluence". The cycle means that buying a house is not an investment as it is in most developed countries. This economic factor also makes it even more difficult to convince builders to invest in more sustainable homes. Yet, there are those who are willing to try. Every project in this book is exceptional and represents the growing number of forward-thinking homeowners, designers and craftspeople who are placing their architectural bets on a more sustainable future. The projects explore innovative and beautiful houses in Japan and abroad that push design and technology in new and old ecological directions.

Chapter 1 considers how bringing nature into the home can make it a healthier, happier and more sustainable living environment. From Yasushi Horibe's framing of nature in the House in Tateshina to the link between house and landscape in Uemachi Laboratory's House in Nara, all projects suggest that nature offers answers to green building issues.

Chapter 2 considers how traditional Japanese architecture is helping reinvent the houses of the twenty-first century. Lessons on how to live more sustainably are taken from a myriad of sources, from the architecture of the Ainu people (Kengo Kuma's Même Meadows) and an Edo-era aristocratic villa (Edward Suzuki's House of Maples in Karuizawa) to a rural farmhouse (Lambiasi + Hayashi's Mini Step House).

Chapter 3 looks at 'smart' houses that aim to make the home as resource-efficient as possible through innovative high- and low-tech design, from Atelier Tekuto's experiments with modern materials to create energy efficiency in the A-Ring House to the passive energy principles of Key Architects' House in Karuizawa.

Wabi sabi aesthetics meet Bohemian design in A1 Architects'
A1 House in Prague (page 222).

Chapter 4 looks at repurposed buildings and renovation projects that demonstrate how old buildings anywhere can be recreated as contemporary, stylish and sustainable, from a dilapidated merchant townhouse in Kyoto turned luxury residence to an old rural farm house given a new life for a young family.

Chapter 5 looks outside Japan for buildings inspired by Japan's eco traditions, from a townhouse in urban Toronto to a forest retreat in Norway and a *wabi sabi* house in Prague.

The Future

Today, particularly since the disasters of March 2011, an ever-growing interest in sustainable living has made environmental design one of the most discussed topics in Japan. Designers, architects and homeowners are reappraising the naturally 'green' qualities of historic Japanese architecture and exploring how it can work with emerging sustainable technology. With this unique mix of past and present, tradition and technology and love of fine craftsmanship and innovation, Japan is in many ways a natural leader in eco architecture. The houses and ideas presented in this book suggest just how Japan could become an international model of sustainability.

Yet, to expand these ideas from individual projects to society at large, political will, far-sighted legislation, corporate compliance and economic investment are needed. Voluntary standards and certification schemes to measure sustainability in the built environment, such as LEED (Leadership in Engineering and Environmental Design) in the USA, BREEAM (Building Research Establishment's Environmental Assessment Method) in the UK and CASBEE (Comprehensive Assessment System for Built Environment

Efficiency) in Japan, all attempt to guide builders into good practices. None are mandatory but grow in influence.

The upcoming 2020 Olympics in Tokyo are expected to bring environmental issues forward. The 1964 Olympics in Tokyo were considered a watershed, transforming post-war Tokyo into a model of modern urbanism, albeit a 1964 model. Many hope 2020 will be just as transforming, readdressing Tokyo's unsustainable development of the past decades. There are proposed plans to reduce car traffic by completing ring roads, to improve the visual landscape by burying the tangle of wires that hover over almost every street and even to remove the elevated highways from above Nihonbashi, the center of historic Tokyo, that were built in the rush to prepare for the 1964 Games, and to increase the use of renewable energy in Tokyo from 6 to 20 percent by 2020.

Many of the houses in this book are built with modern materials and techniques, yet all express some aspect of the traditional dynamics of Japanese architectural space and sensibilities. This desire to connect to a more sustainable past to build a more sustainable future is growing, particularly among younger generations who have grown up in dense urbanism and for whom old ways are intriguingly new. But as society turns green, will the wider construction industry follow? Japan builds some of the most advanced, seismically sound buildings in the world. Can it start to build some of the most sustainable? With a built heritage that is a model of sustainability, a recent history that is not and a new generation concerned for the future, Japan has choices to make. As shown by the projects, houses and homeowners in this book, Japan has the tools needed to lead the way internationally to a more sustainable built environment. The question remains, will it?

Traditional Ainu architecture meets high-tech construction in Kengo Kuma's Même Meadows (page 116).

BORROWED LANDSCAPES
PUTTING NATURE IN THE DESIGN

This section looks at projects that incorporate nature in the design, quite literally, whether by including actual trees and gardens as natural 'green curtains' or by employing the age-old Japanese concept of *shakkei*, or 'borrow landscape', in which exterior nature views are made part of the interior experience of the home.

Architecture and nature were closely linked in traditional Japanese building. In pre-modern Japan, houses were made of renewable natural materials and gardens were features in high-end houses as well as at the heart of dense working-class city blocks. The dense concrete urbanity of contemporary Japan has taken much of the green out of everyday life. A garden has now become something one occasionally visits.

American biologist and naturalist E. O. Wilson has hypothesized that human beings have an instinctive bond with other living systems, that is, nature. According to Wilson, "Nature holds the key to our aesthetic, intellectual, cognitive and even spiritual satisfaction." Our living spaces should reflect this natural affinity, bringing in natural light, fresh air and a sense of place.

Can bringing nature into the home really make people happier and homes healthier and more sustainable? These projects suggest that it does. Yasushi Horibe's House in Tateshina frames nature as an ever-changing work of art. Uemachi Laboratory's House in Nara echoes and embellishes its tranquil garden setting. With a small footprint, natural materials and a unique design open to and respectful of its verdant and historic environment, acaa's House in Kita-Kamakura adds to the already abundant beauty of its surroundings. Rhythmdesign's House in Raizan Forest floats on a hill in a forest, creating tree-filled views and the lightest footprint possible. And in a dense Tokyo suburb, architect café brings a bit of rural greenery in its House in Komae.

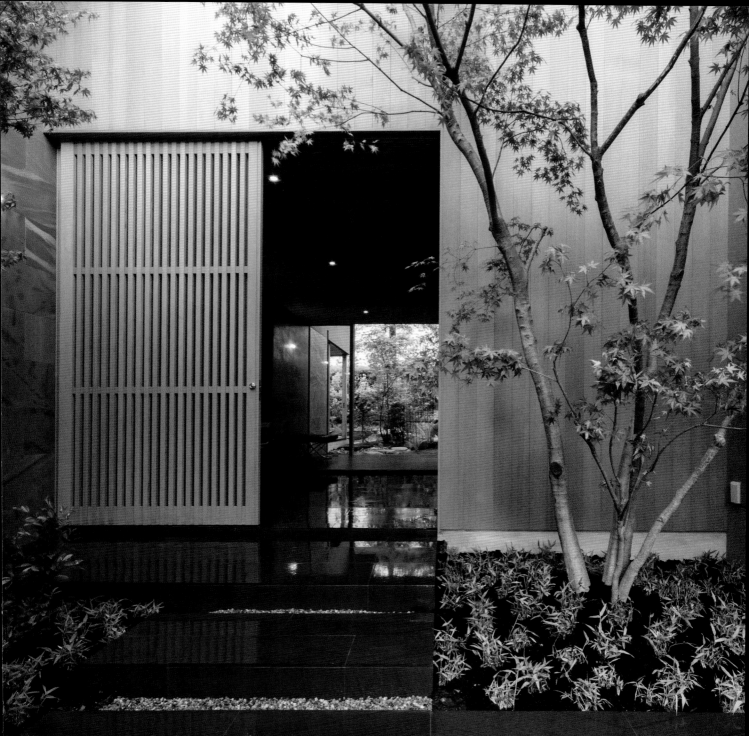

HOUSE IN KITA-KAMAKURA

ARCHITECT **ACAA—KAZUHIKO KISHIMOTO**

LOCATION **KITA-KAMAKURA, KANAGAWA PREFECTURE**

COMPLETION **2008**

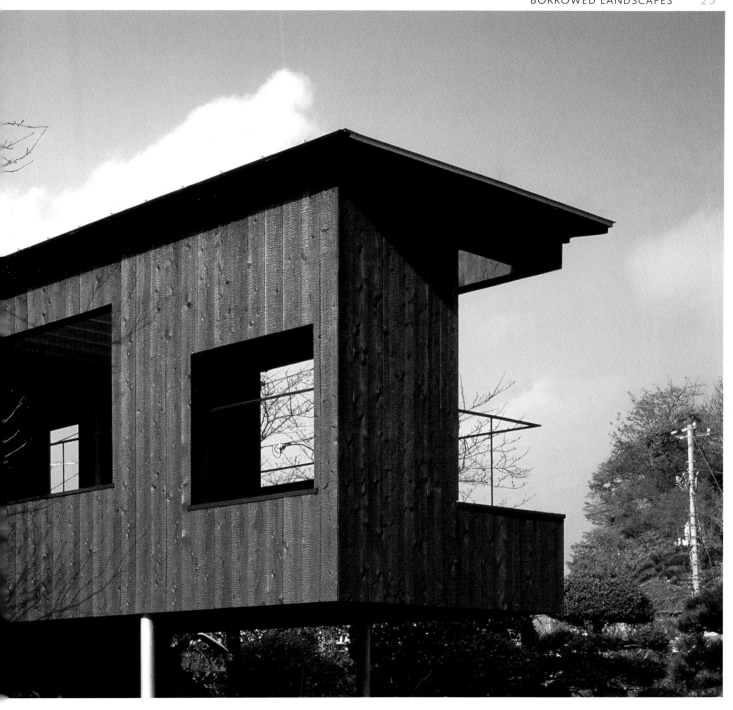

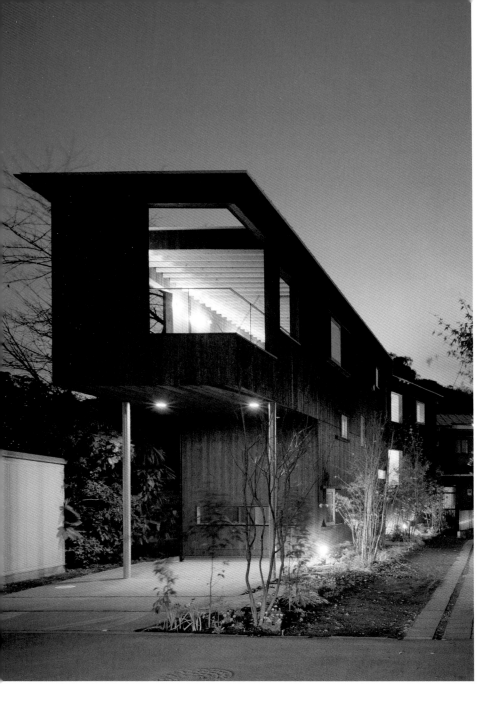

This house is set in one of the loveliest parts of Kamakura, an ancient capital encircled by rolling green hills and the sea. Modern Kamakura is a lively community attracting an eclectic mix of artists, artisans, surfers, Zen Buddhists and quite a number of young architects, inspired by the traditional architecture and creative atmosphere of the area. Within commuting distance of Tokyo, it is a place where many dream of having a house. Unsurprisingly, space is limited and land hard to find and expensive. So when you have a plot in the very sought-after area of Kita-Kamakura (North Kamakura), you do not quibble about an irregularly shaped site, you simply figure out how to make the most of it.

To this end, the owners chose wisely in architect Kazuhiko Kishimoto, founder of architectural studio acca. Specializing in residential architecture, acca's approach mixes an international outlook with a strong sense of place. Kishimoto considers the house as the purest expression of architecture's relationship with the land. He credits the work of Australian architect Glenn Murcutt, known for articulating the qualities of site into architecture, as an influence on his own designs. Likewise, acca pays close attention to the precise setting, environment and climate of each project and works closely with those who do the physical building: the carpenters, metalworkers and plasterers. Their designs offer contemporary interpretations of

vernacular forms with a decidedly Japanese focus on detail and craftsmanship. The result is a portfolio of finely wrought houses that fit beautifully into their surroundings.

Kita-Kamakura is characterized by a series of narrow valleys with tendrils of roads dotted with temples, shrines and individual homes. This house is located not far from a Buddhist temple dating to the fourteenth century, the picturesque Meigetsu-in. The valley leading to the temple features several distinct houses, none more eye-catching than this elongated structure. The plot is long but, due to zoning regulations the building's footprint must be less than three meters wide. In such a tight spot, it is important to build with respect for neighbors, creating something that participates in and adds to a verdant but densely populated area.

ACAA makes the most of this unusual plot, giving the house a curved serpentine footprint and an elegant two-story profile 23 meters long and a mere 2.7 metres wide. The exterior's cladding echoes the Japanese charred wood technique, which was traditionally used for water-, fire- and bug-proofing (see page 232). Silvery black wood articulates the exterior, catching the light at varying angles along the home's undulating façade. Glimpses of a light wood interior add to the asymmetrical rhythm of the profile.

Irregular openings add expression to the exterior and help to control light, heat and

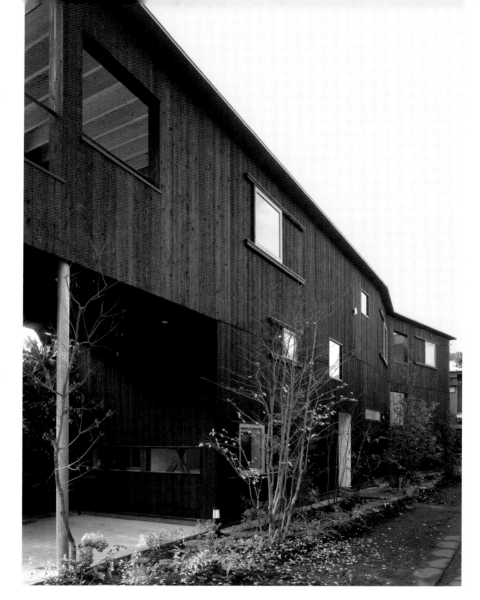

Previous spread Asymmetrical openings are strategically placed for function as well as creating a playful profile to the neighborhood.

Opposite The balcony juts forth, creating a sheltered parking space below.

Above The blackened vertical planks balance the horizontal line of the house.

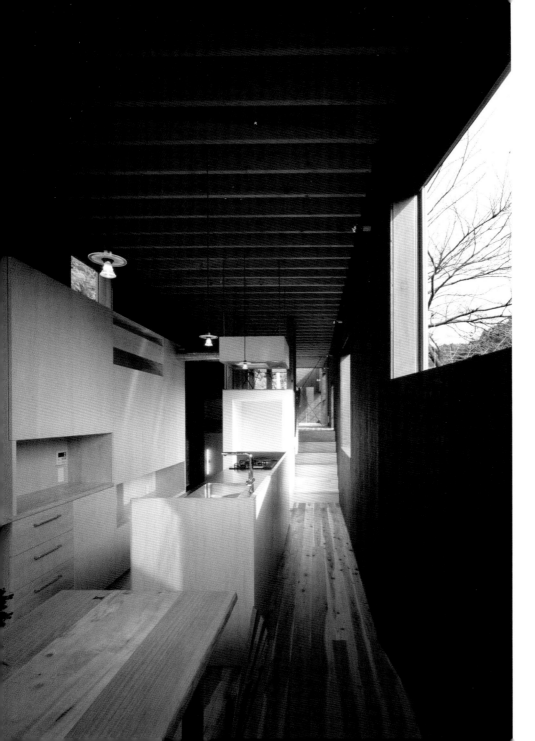

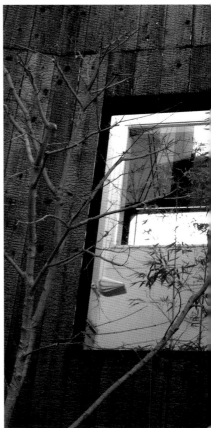

Left The upper floor kitchen leads to a raised sitting area.
Above Bamboo grows in the interior courtyard.

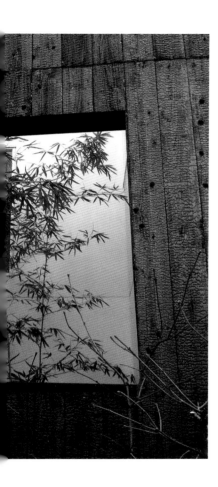

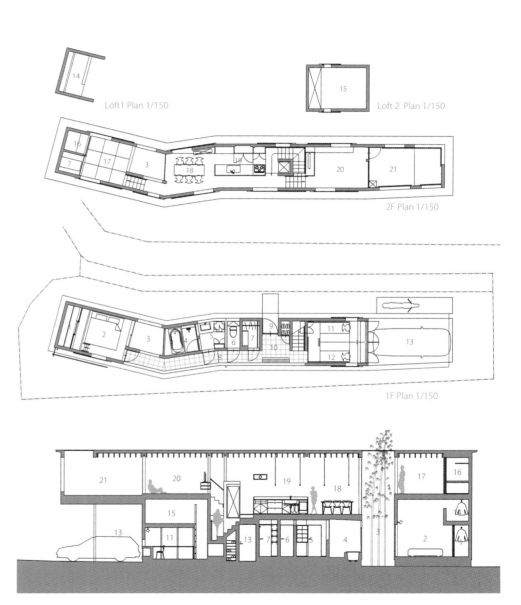

Loft1 Plan 1/150

Loft 2 Plan 1/150

2F Plan 1/150

1F Plan 1/150

Right Plan and cross-section: The house may be only three meters wide, yet the house has 108.06 square meters of living space over various levels.

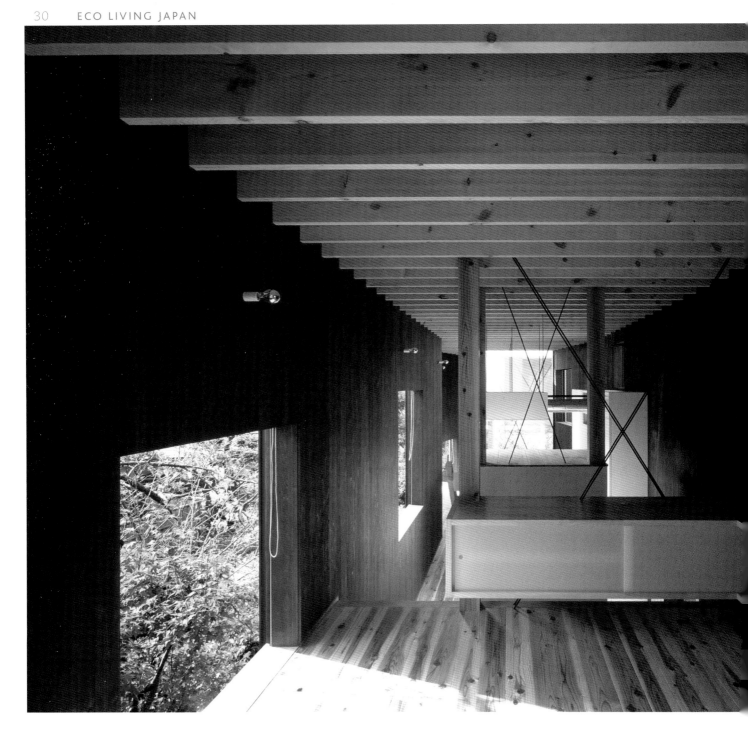

Left Dark and light woods contrast throughout and are complemented by leafy views.

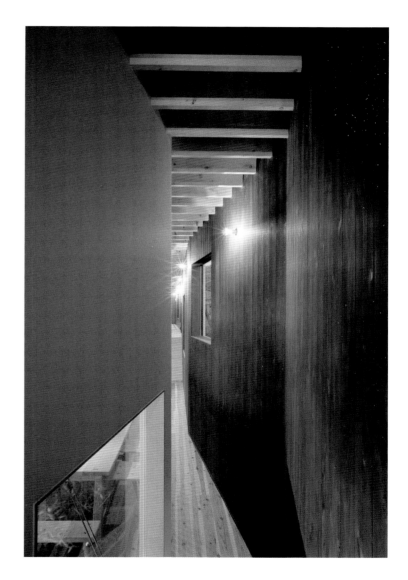

Right The house's curved serpentine footprint creates unique site lines.

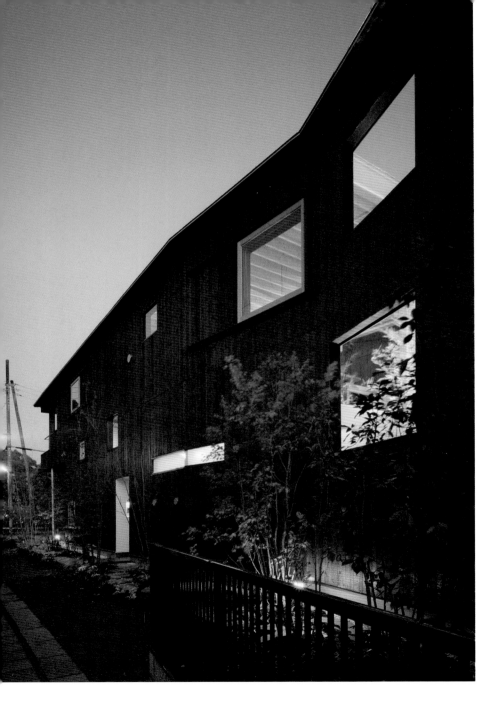

privacy in the interior. Inside, the surrounding landscape comes from varied angles as each window is carefully placed to optimize views from the interior and maximize privacy from the exterior.

With a site area of 173.92 square meters, the house creates 108.06 square meters of floor space. The space of the lower floor is defined by stained black wood, while upstairs is light and open. Ceiling heights vary throughout, creating spaces that are at once open but still offer a degree of privacy. The layout has unexpected connections and inclusions. For instance, a small glazed courtyard sits between the family space to the front of the house and the tranquil back end that contains the main bedroom and *tatami* room above. Filled with bamboo trees, the courtyard allows light to filter in from above, giving even the most private nook of the house dappled leafy natural light all year round.

Like the prow of a ship, a front-end balcony juts out overlooking the neighborhood to the forested hills beyond. Openings above and to the side continue the structure's play of open and closed, public and private, while removable *sudare* blinds can block summer heat. The balcony is balanced on slim pillars, creating shaded exterior space below.

The overall asymmetrical design creates a sense of balance: contrast + contrast = visual harmony. With a small footprint, natural materials and a unique design open to and respectful of its lush and historic environment, the house adds to the already abundant beauty of its surroundings.

SMALL FOOTPRINT
NATURAL MATERIALS
BORROWED LANDSCAPE
RESPECTFUL OF CONTEXT/GOOD NEIGHBOR

Below left Views of the verdant Kamakura hills from the kitchen/dining area.
Left and below The bamboo courtyard adds interior green and visually connects the varying areas and levels of the house.

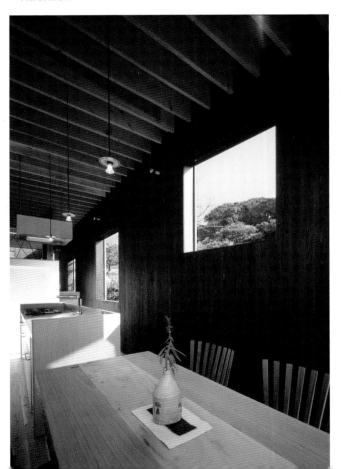

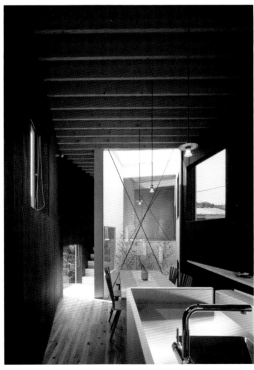

HOUSE IN KOMAE

ARCHITECT **ARCHITECT CAFÉ—
MIKIO TAI**

LOCATION **KOMAE, TOKYO**

COMPLETION **2013**

The House in Komae's design aims to
create a countryside-like atmosphere in
a dense suburb of Tokyo. The architect,
Mikio Tai, founder of architect café, took
inspiration from the Japanese *engawa*
(see page 80), an intermediary corridor-
like space between house and garden in
traditional *Shoin* architecture, to explore
how the house would interact with its
surroundings in all four seasons. As the
architect explained: "Though the area
has many green and vacant spaces, most
buildings are closely packed," leaving
little space for green. In order to bring
a sense of nature into the daily life of
the house, he aimed to "create a new
relationship between inside and outside".

The house plot, at 257 square meters, is
relatively large for Tokyo. Land is expensive
in Tokyo and thus most builders try to use
every centimeter of ground permitted by
law to build the biggest house possible. The
House in Komae's design bucked this trend

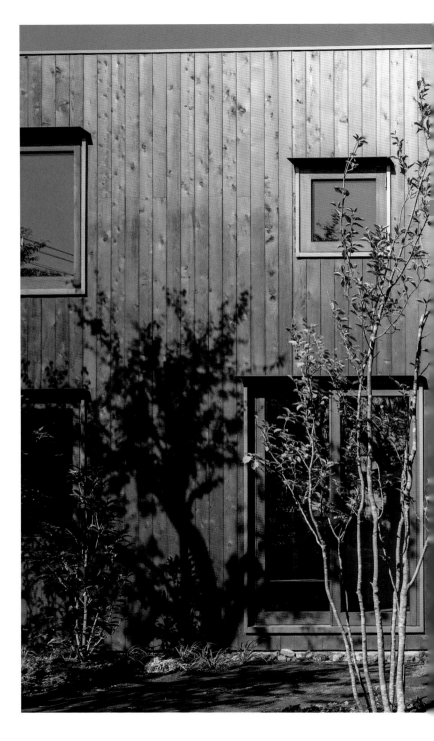

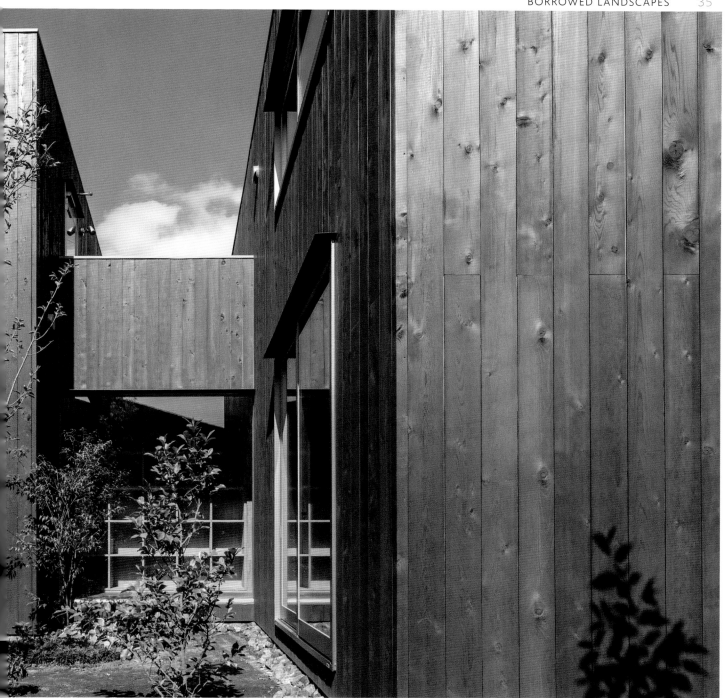

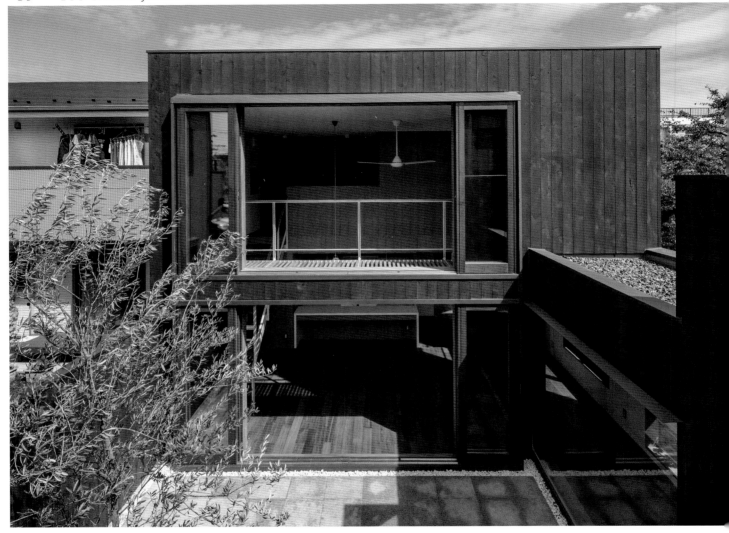

and instead offered a multi-part house plan occupying less that half of the site (only 101 square meters), leaving the rest of the land for trees, garden and exterior courtyards. The result is a unique two-story home with 154.66 square meters of living space and green views from every room.

Clad in red cedar, the house is composed of four boxes of different sizes and functions that are connected to each other by ancillary corridors, exterior courtyards and a long garden along the east side of the house. The layout is designed to ensure all spaces open to courtyards and/or gardens.

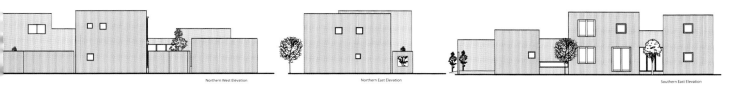

Northern West Elevation

Northern East Elevation

Southern East Elevation

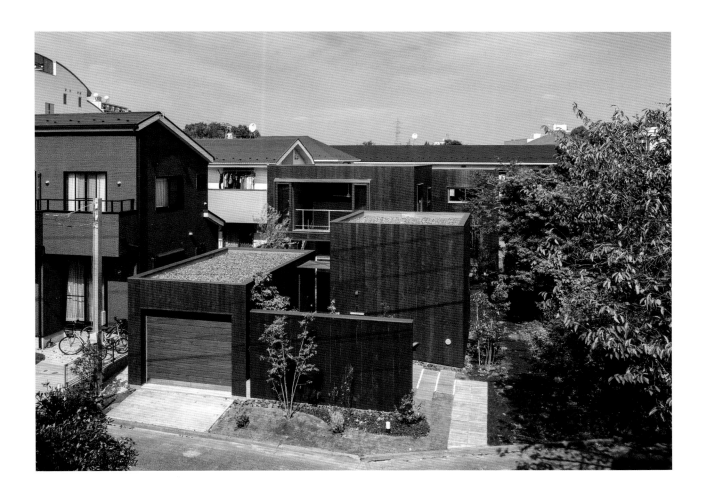

HOUSE IN NARA

ARCHITECT UEMACHI LABORATORY
LOCATION NARA, NARA PREFECTURE
COMPLETION 2014

Uemachi Laboratory has an admirable practice policy of creating living spaces that embody *wa*, or 'harmony'. In a recent project in the ancient capital of Nara, Mitsumasa Sadakata, director and founder of the Hyogo-based firm, demonstrates just how this policy is put into action.

The House in Nara is located in a quiet residential area of the historic city of Nara, famed for its temples and shrines in verdant settings. The clients, a family of five, had varied needs but one core request: to be able to see greenery from every room in the house. For Mitsumasa Sadakata, this became the theme of the house. Uemachi Laboratory worked with Japanese landscape architects Araki Design to create a composite project that makes the house part of the landscape and the landscape part of the house.

The unobtrusive street façade sits low on the land with hints of green peeping out from behind low-pitched roofs and slatted wood partitions. At night, soft light spills out through slatted screens, like a glowing lantern welcoming the residents home.

Previous spread Soft light slips out through slatted wood screens, creating lantern-like effects at night.
Right The integration of garden and architecture begins at the entryway.

The play of light and shadow continues inside with large glazed openings dissolving boundaries between interior and exterior in a contemporary nod to the traditional technique of *shakke*i, or 'borrowed landscape', in which exterior views are made part of the interior experience of the house by the careful placement of openings.

Throughout the house, a mixture of broad windows, glass sliding doors and slatted wood and *shoji* screens frame varied views of Araki Design's mossy gardens, mature trees and flagstone paths. Each room and corridor offers a different experience of the surrounding nature, framing views like works of art. Carefully placed overhanging eaves, wooden slats and greenery also add passive solar qualities (see page 138), helping to heat the house in winter and minimize sun in summer.

The entryway presents a mix of elegantly framed greenery, handcrafted natural wood and polished stone that is repeated throughout the property. The lines of the wooden planked ceiling of the entryway continue into the living area whose long contiguous window fills almost an entire wall. The living area, in turn, opens up to a double-height kitchen and dining area with its own slatted ceiling and handcrafted

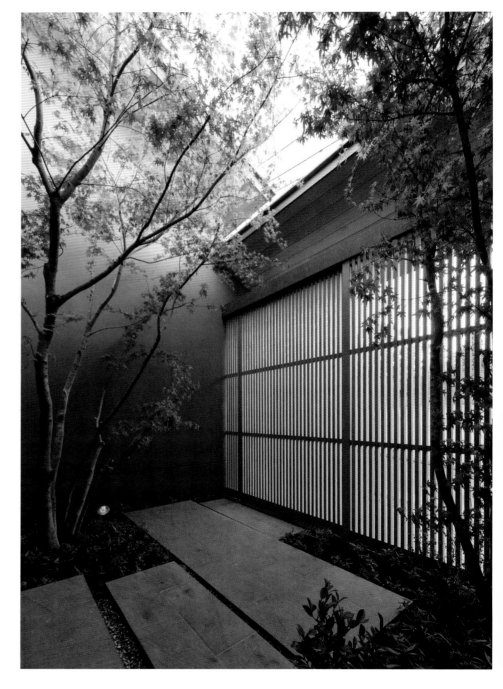

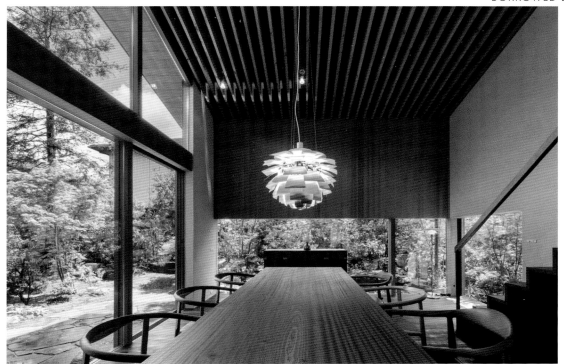

Above Dining with nature. Each space offers a different experience of the surrounding nature. **Right** House in garden plan.

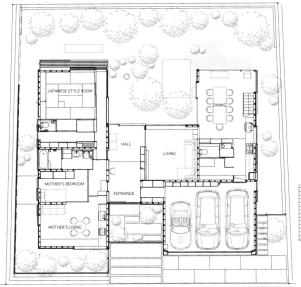

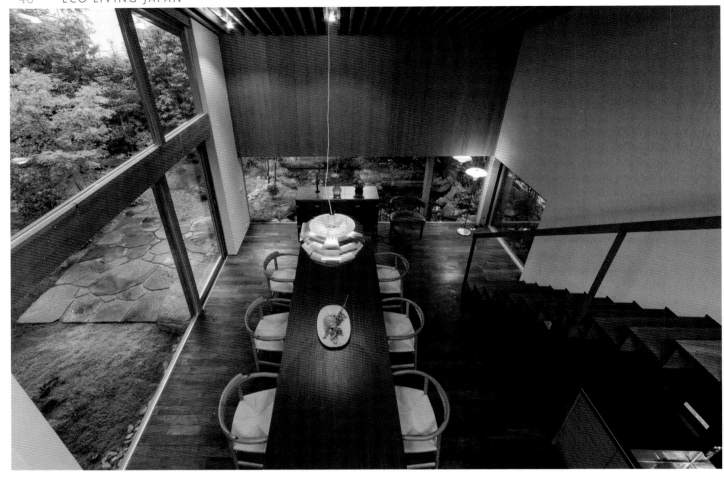

Above Huge windows surround the dining area, bringing the garden inside and offering an elegant blend of textures and materials.

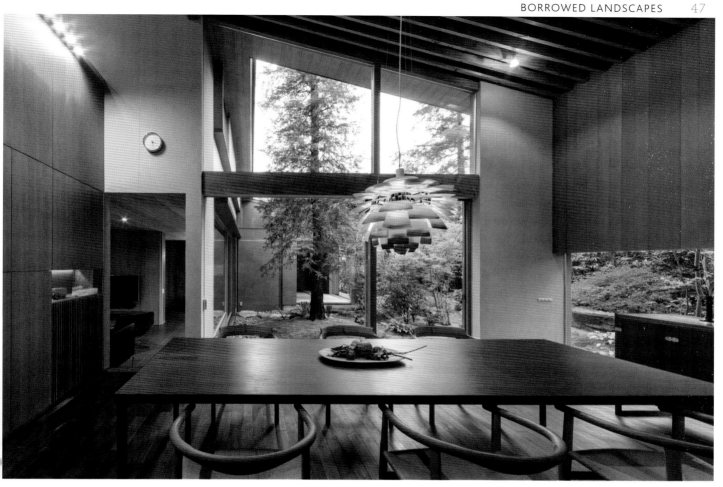

Above The double-height dining area with its handcrafted wooden chandelier.

Left The eat-in kitchen echoes the elegant styling and materials of the rest of the house.

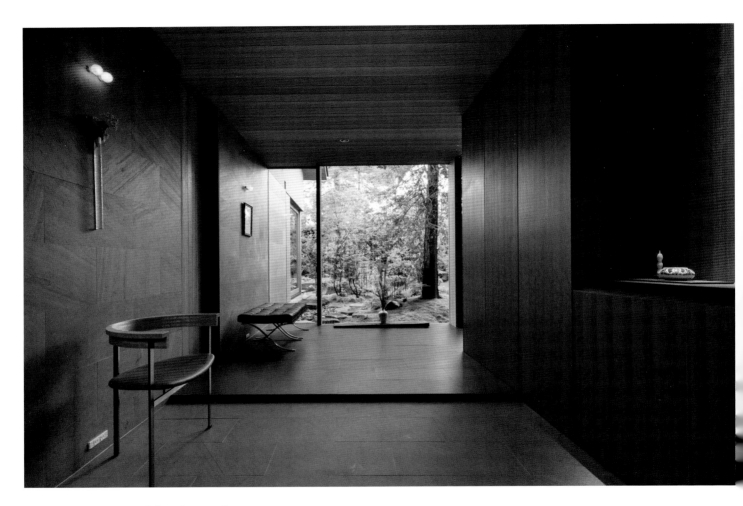

Above The entryway ends in a glass opening,
which frames the garden like a work of art.

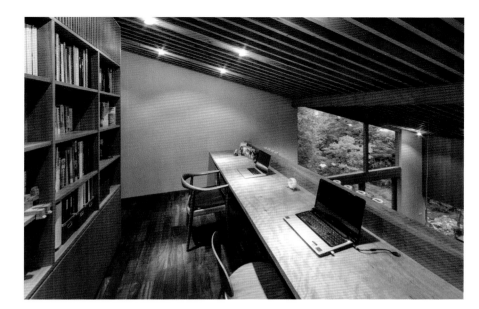

Left A built-in library overlooks the dining area.
Below The house includes a self-contained living room and bedroom on the ground floor.

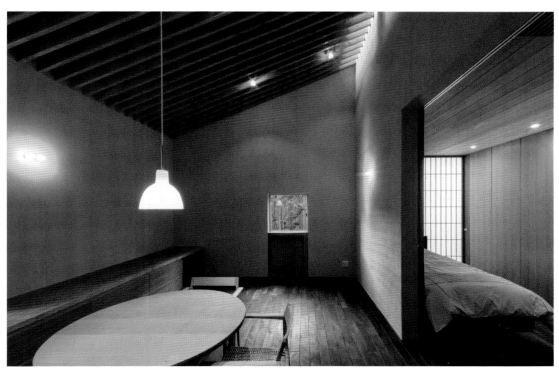

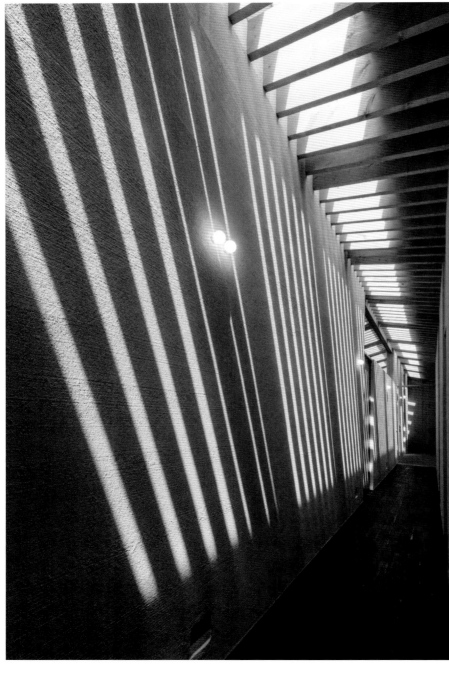

wooden chandelier. Huge windows surround the dining area, bringing the gardens inside. Everywhere, the gardens seem to envelop the house, wrapping it in a green embrace.

Opposite the dining area, an elegant *tatami* room designed for the tea ceremony opens onto a transitional space between interior and exterior, a modern interpretation of the *engawa* (see page 80), a passageway between garden and interior flanked by movable *shoji* and slatted wood screens. For the traditional performance of *sadō* (tea ceremony), participants can enter the *tatami* room via the garden, by the *chouzubachi* (ceremonial stone water basin) and remove their shoes at the *kutsunugi-ishi* (shoe removing stone). The timber slats throughout provide shade in the summer heat and diffuse natural light without sacrificing privacy.

It is a house of atmospheric light and shadow. Mitsumasa Sadakata has written that wooden screens offer light "filtered through nature", adding a distinctly poetic aspect to the design. Mixing beauty, context and function, the House in Nara is designed with respect for materials and the environment, creating a contemporary home steeped in tradition and nature.

ECO MATERIALS
PASSIVE SOLAR
CONNECTION OF NATURE AND ARCHITECTURE

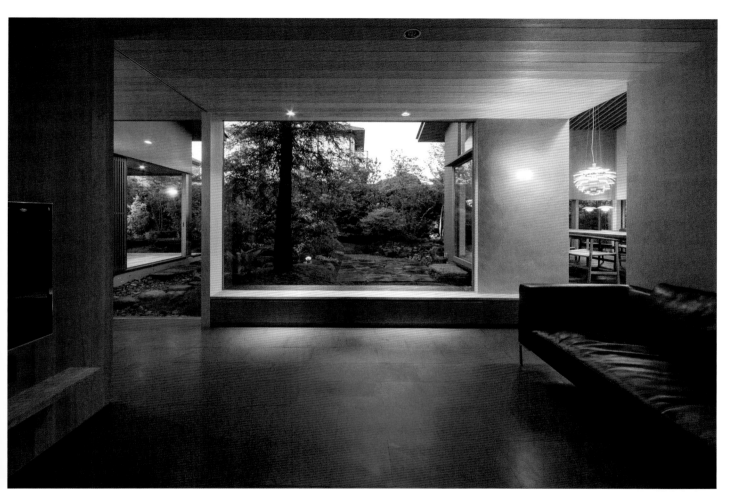

Above Public spaces flow into one another. The ground floor living area opens onto the gardens, which are flanked by the dining area and *washitsu*, or traditional Japanese room.
Opposite Wooden slats moderate light from skylights.

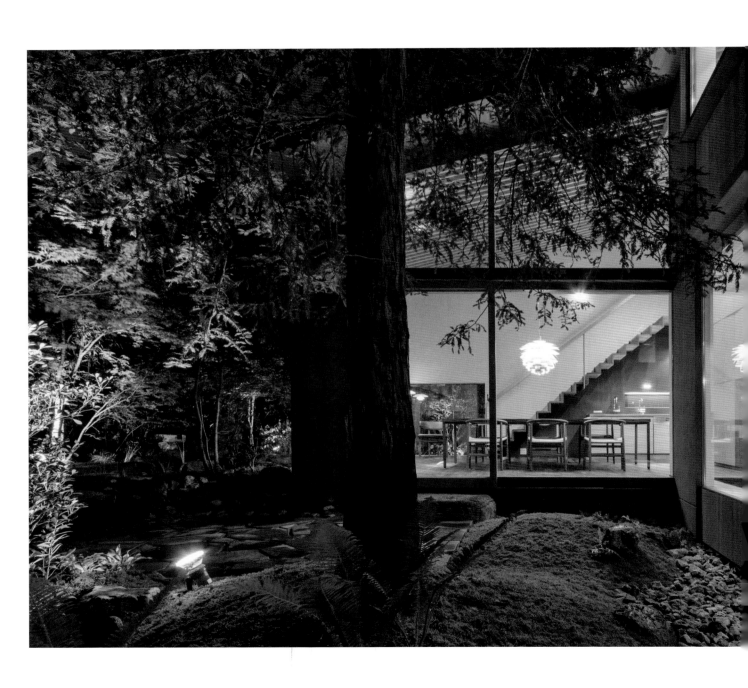

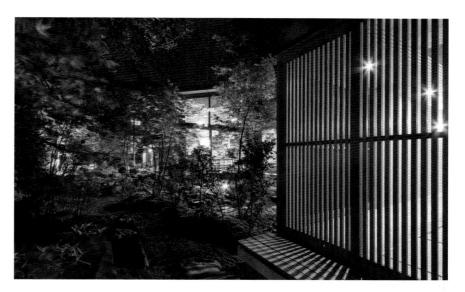

Left The garden and the mature trees provide a lush contrast to the elegant lines of the interior.

Above Wooden slats and greenery add to the dappling of light and shadow.

Below The façade sits close to the land under low-pitched roofs and behind wooden partitions.

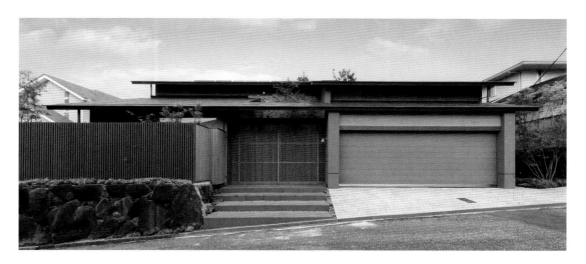

HOUSE IN RAIZAN FOREST

ARCHITECT RHYTHMDESIGN—KENICHIRO IDE
AND YUTA KINAI

LOCATION ITOSHIMA, FUKUOKA PREFECTURE

COMPLETION 2012

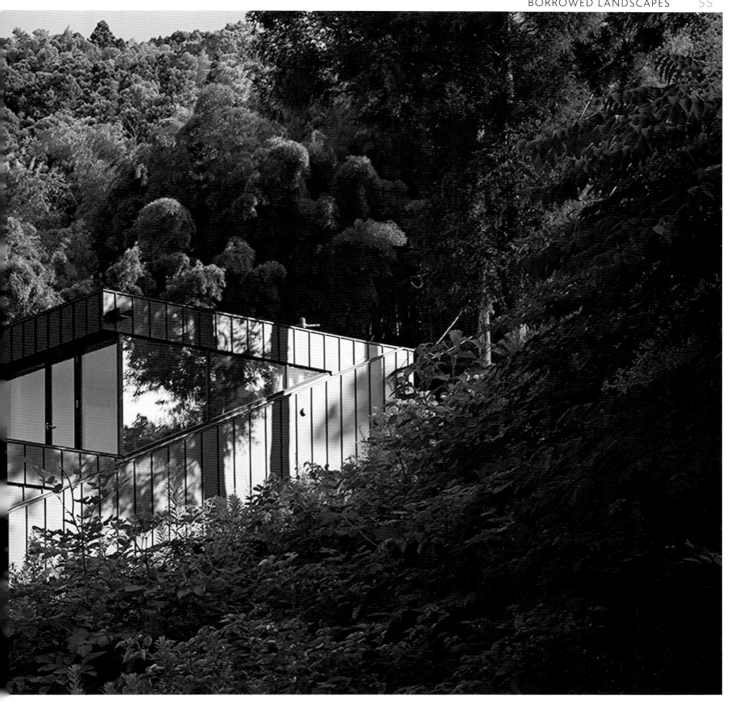

For this family holiday home on a forested hillside, Kenichiro Ide and Yuta Kinai of rhythmdesign created a structure with the lightest footprint possible.

The house is located in the resort area of Itoshima, about a 30-minute drive to the west of Fukuoka on the southern island of Kyushu. The area is known for its hot springs and has hot, humid summers and cold, snowy winters. While the plot of land is quite large (over 900 square meters), it had never been built upon, mostly likely because of its challenging topography. It is all hillside, with over 14 meters of elevation change. Nevertheless, the architects aimed to maintain as much of the original virgin landscape as possible, which includes numerous mature Japanese cypresses, and

Previous spread The house is nestled into a forested hillside.
Right To create a light footprint, the house is designed like stairs climbing a hill.
Below The cross-section reveals how the tripartite home is anchored into the hillside.

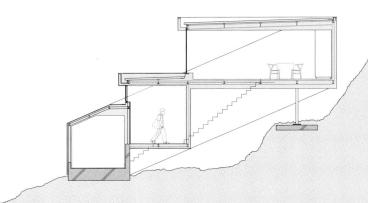

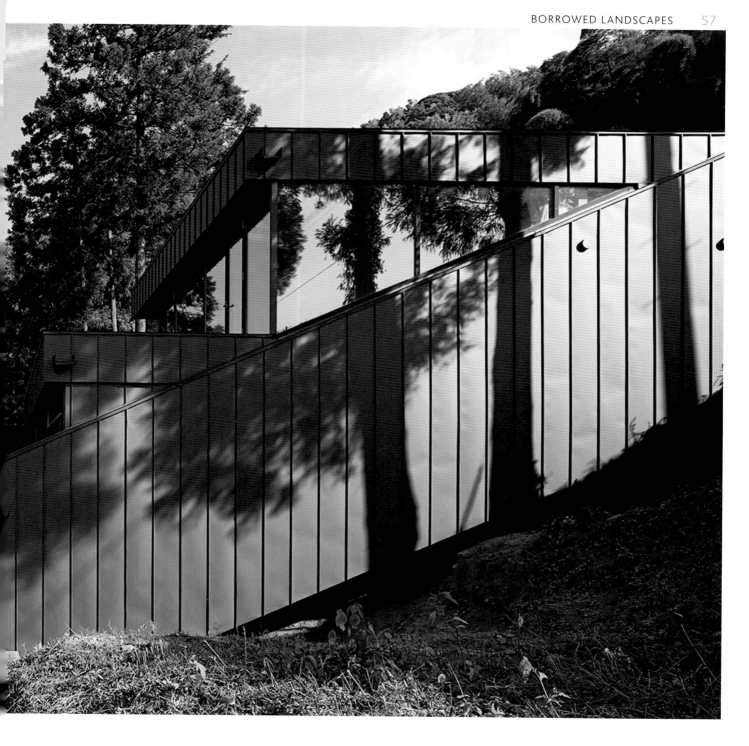

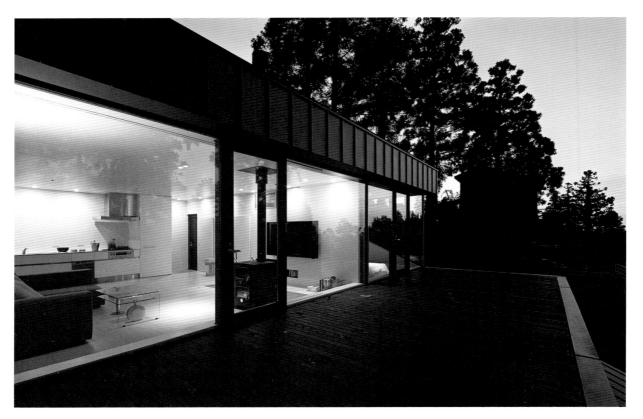

Opposite above The home's rectilinear profile highlights the tall Japanese cypress trees that surround it.

Opposite below The slanted underside of the house is elevated to minimize impact on the land and provide natural air circulation.

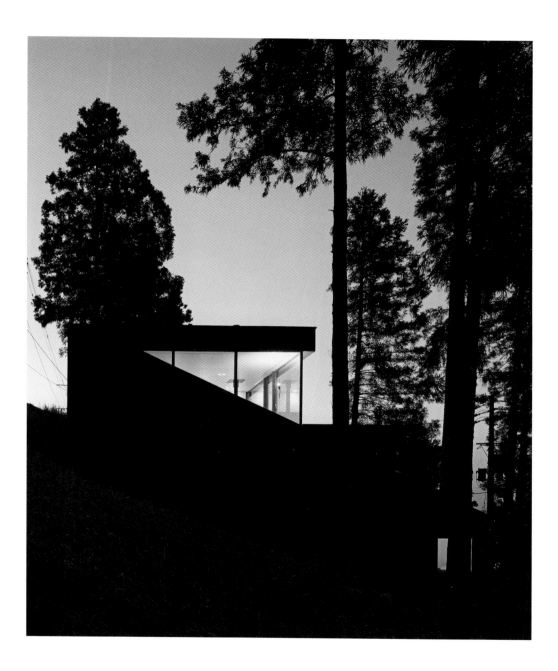

Right At dusk, the body of the house melts into the shadows.

HOUSE IN TATESHINA

ARCHITECT YASASHI HORIBE ARCHITECT & ASSOCIATES
LOCATION CHINO, NAGANO PREFECTURE
COMPLETION 2010

Previous spread Horibe's work itself is often called "quiet", reflecting his thoughtful approach to space and materials.
Left The site is tree-covered but with neighbors on three sides.
Below Plans of the square three-level house.

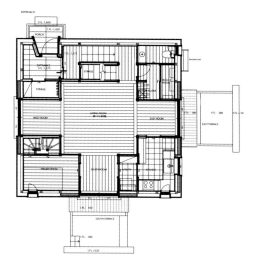

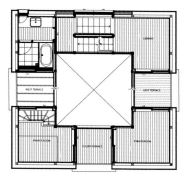

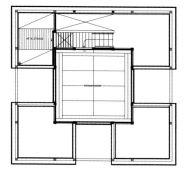

Over two decades and more than 70 houses, Yasushi Horibe has quietly made a name for himself producing unassumingly elegant houses filled with expressive spaces and a deep sense of place. He designs houses for the context they inhabit, be it a luxuriant forest or a dense urban setting. "It depends on the timing, people and location," explains Horibe. His work is often called "quiet", reflecting his thoughtful approach to space and materials. The key to his success is a reputation for building houses that are highly livable, in which function and comfort come before pure architecture.

This exquisitely crafted house on a gently sloping site in the Nagano Alps is typical of his work. A weekend getaway for an extended family, the house needed to respond to the multifunctional use of several generations; the site, which is tree-covered but with neighbors on three sides; and the snowy alpine climate.

The house plan is based on the square, not the more common rectangular form. It is a half-timber construction (*shinkabe-*

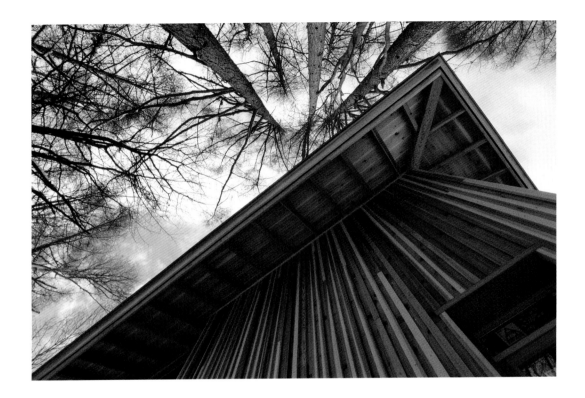

Left The exterior surface is articulated by vertical cedar cladding and overhanging eaves.
Right The square structure is punctured by deep openings, each carefully placed to frame selected views.

zukuri) with a Japanese cedar structure and interior walls and floors of sawara cypress. The entire house is a study in the expressive qualities of wood, space and light.

The exterior surface is articulated by vertical cedar cladding, deep openings and overhanging eaves. With neighbors on three sides, openings were carefully placed to frame selected views. The house enters into a friendly dialogue with its surroundings, presenting an attractive yet discrete face to its neighbors. From the south, east and west, openings take the shape of light tunnels radiating from the central living room square. The windows frame views in such a way that they offer both direct and indirect light and pleasing views as well as a degree of privacy.

The interior surfaces of the house reflect the dappled light and shadow of the forested surroundings. Windows 'borrow' the landscape for the interior, creating new, almost intensified views of its forest setting. "Architecture cannot exist without a relationship, a relationship with what people want, with nature and climate, with economy, with the character of the site, with the neighboring houses, streets and cityscape, with laws, with the times," expounds the architect.

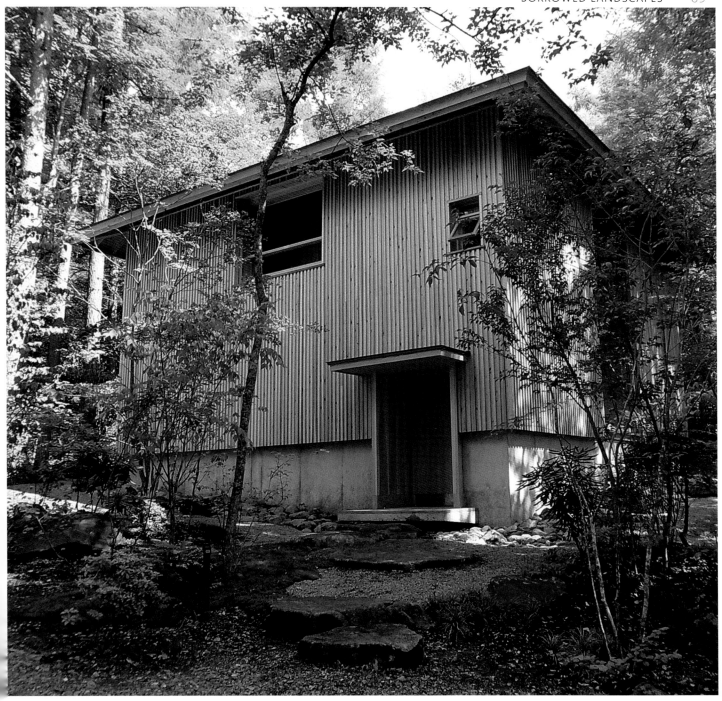

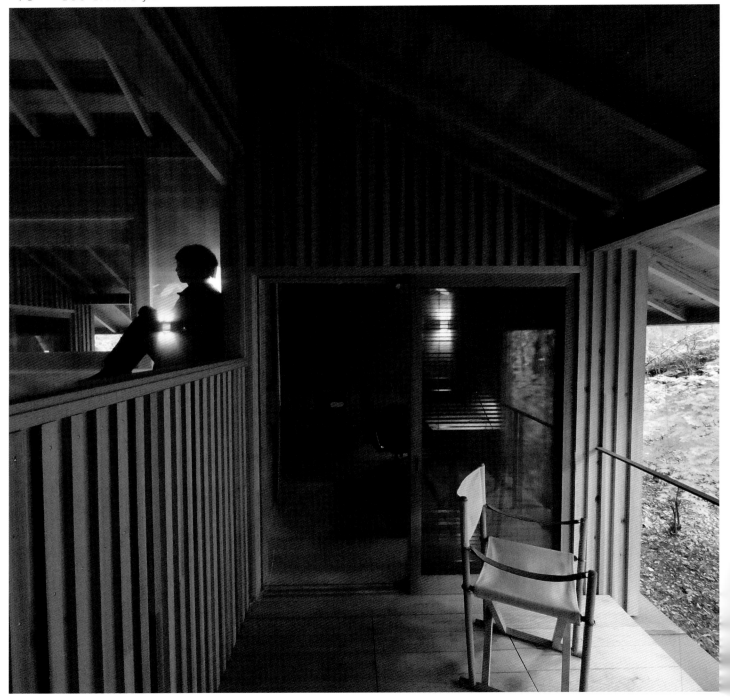

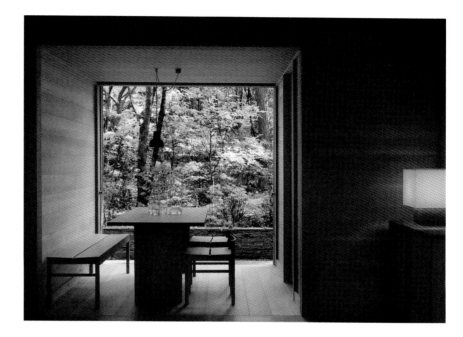

Left Over the living area is a large *tatami* room surrounded by elegant wooden screens that can be opened in fine weather.
Below The expressive use of wood, space and light in the interior creates both a cool summer and cozy winter space.

Above A cubic dining area artistically frames the landscape.

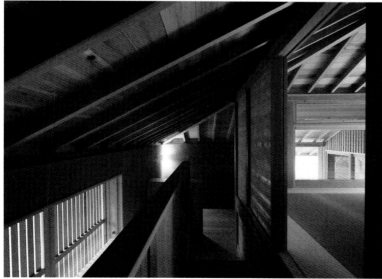

The interior has 136 square meters of living space spread over three stepped levels. The ground floor is arranged around an extra high central living area with private rooms for sleeping tucked behind sliding doors. Open wooden steps lead up to a second donut-holed level that alternates rooms and terraces. Above, over the living area, is a large *tatami* room surrounded by elegant wooden screens that can be opened. Passages feature beautifully crafted wooden steps and slatted screens that allow light and air to easily flow.

Horibe's preferred materials are natural: wood, *shoji* paper and *tatami*. "I like to use the materials I've known since I was a child," he says. "I can trust them because I know their pros and cons." He uses them here in the snowy alps to create a warm, cozy house of light and shadow.

ECO MATERIAL
NEIGHBORHOOD FRIENDLY
PASSIVE DESIGN PRINCIPLES BASED ON CLIMATE

Left Horibe's designs are noted for their expressive yet highly functional spaces. **Right** Translucent blinds offer a variety of ways to experience the interior space, reflecting weather, season and mood.

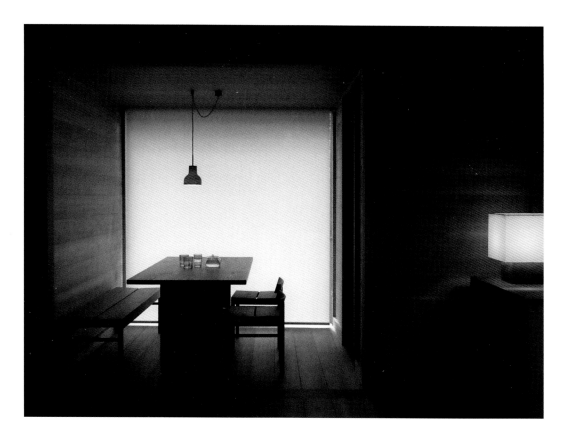

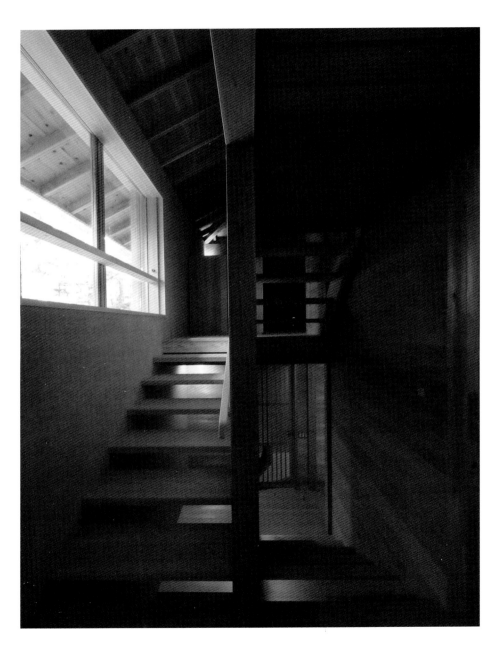

Left Open wooden stairs lead up to the open, multipurpose attic space.

Right The ground floor is arranged around an extra high central living area with private rooms for sleeping tucked behind sliding doors.

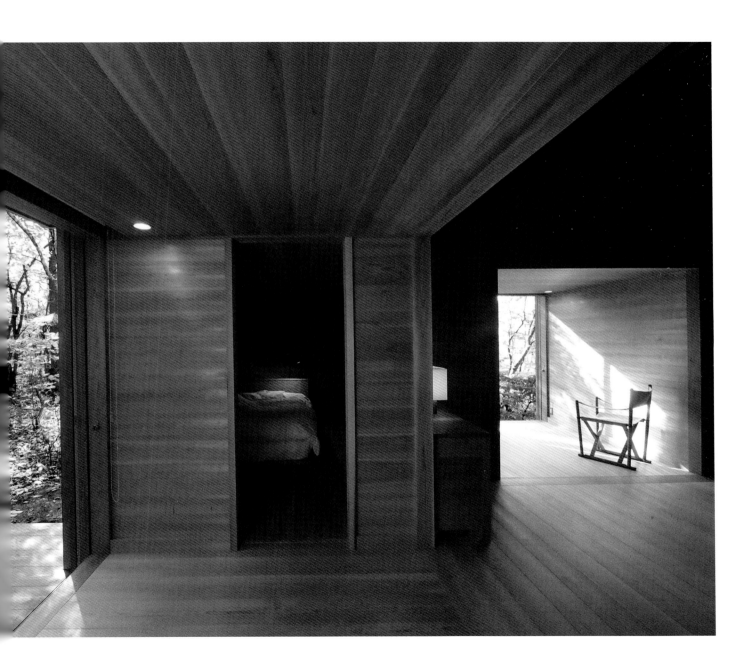

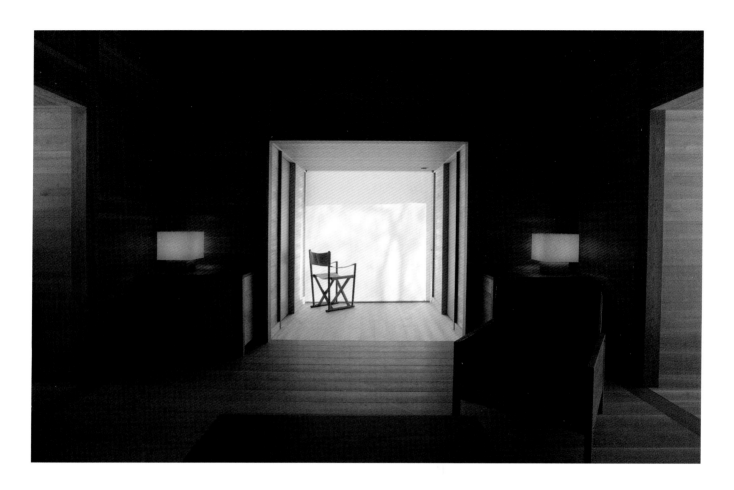

Left The house's interior surfaces reflect the dappled light and shadow of the forested surroundings.
Right The deep openings capture the low light of winter.

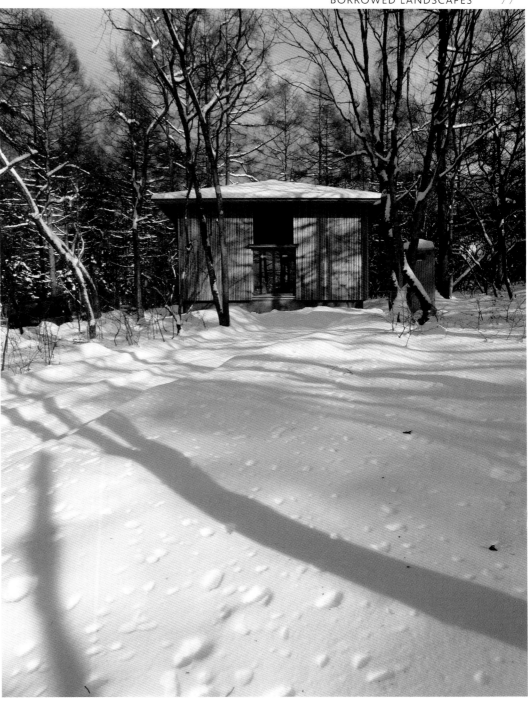

GREEN CURTAINS

MAKING NATURE WORK FOR THE HOME

Dealing with summer heat is a major preoccupation of Japanese homeowners. While various modern methods of cooling are in use, more traditional low-tech methods are being encouraged, especially after the nuclear disaster in Fukushima in 2011, which made energy efficiency a national issue.

Pre-modern Japanese houses often used light removable trellises of wood, bamboo or rope covered with climbing foliage to help shade their homes. These 'green curtains' offered shade as well as flowering color with plants like morning glory and/or food such as beans or squash. Recently, several local councils have begun to encourage residents to grow climbing plants like goya (a bitter gourd popular in summer) to help reduce the need for energy-high cooling methods, such as air conditioning. Some even offer free trellis kits with pots, netting, dirt and seeds, while others have teamed up with NGOs to provide workshops for those who want to learn how to create an effective green curtain.

On south-facing walls, for example, where the sun hits from a high angle, green curtains should be created on a slant to make the largest possible shadow, while on east- or west-facing walls, green curtains should be hung vertically as the sunlight hits the wall more directly. All this effort has a large payback: well-placed trellises can reduce interior temperature by as much as two degrees. In turn, cooler room temperatures mean a reduction in air-conditioner energy use and an overall reduction of CO_2 emissions.

Architects like Kengo Kuma often incorporate chic versions of these home-grown curtains into major designs. Kuma's Nezu Museum in Tokyo's stylish Aoyama neighborhood has a long exterior entrance corridor sheltered by broad overhanging eaves and shaded and cooled by a wall of bamboo. The walk along the bamboo alley refreshes and transitions from the urban bustle of Aoyama to the tranquility of the museum space. Not far away, Danish-born floral artist Nicolai Bergmann's flagship store and café, Nomu (http://www.nicolaibergmann.com/locations), is defined by a living green wall that functions not only to cool and refresh the air but also as

a floral art gallery, with exhibits changing with the seasons.

This 'living curtain' concept has also been adapted in large institutional projects, ranging from schools to office blocks. Since 2005, Tokyo has promoted a Green Building Program to combat the intense urban summer heat by adding greenery on top and around large buildings. The cooling effect of shade, natural insulation and greenery reduces the use of air-conditioning and beautifies the surroundings. Students and workers are often encouraged to help maintain the gardens and trellises. In return, they get fresh air, exercise and a sense of connection to nature, tradition and smart energy use.

Opposite, clockwise from top left Enveloping greenery shades and cools a gateway. A living wall of bamboo shields the Nezu Museum's elegant entryway. A flowering trellis climbs the front of a house, offering shade and color. A seasonally changing green wall in Nicolai Bergmann's Tokyo café/shop Nomu.

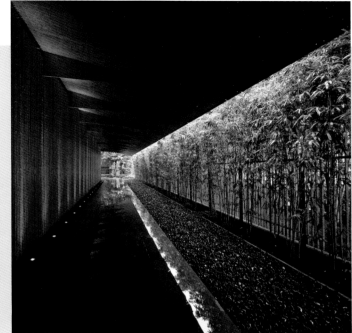

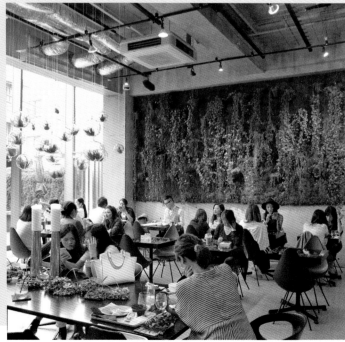

THE MULTIPURPOSE ENGAWA
A TRADITIONAL SPACE BETWEEN INSIDE AND OUTSIDE

In traditional Japanese architecture, the *engawa*, variously translated as 'veranda', 'open corridor' or 'balcony', is found in many contexts but generally functions as an intermediary space between interior and exterior. It is often a raised wooden terrace that follows the line of the house (see photo opposite, lower right). Set under protective eaves, it opens to the interior wood and/or *tatami* rooms and to the exterior space, often with some form of removable sliding door (see photos opposite, upper right and lower left). In farmhouses (*minka*), the *engawa* opened onto the work yard; in merchant townhouses (*machiya*), they might open to a small pocket garden or communal space (see photo opposite, upper left); while in aristocratic or samurai Shoin- and Sukiya-style houses, they opened onto a private formal garden (see photo opposite, lower right). In these differing domestic spaces, engagement between the house and its surroundings via the *engawa* was central to the home's design and function. The *engawa* is both inside and outside, public space and private space, its connections moderated by sliding screens or doors of varying levels of transparency. In fine weather, screens/doors open to bring views, visitors and fresh air inside.

This close connection between architecture and nature is a concept that flows throughout the history of Japanese architecture, both sacred and secular. The famous eleventh-century Phoenix Hall near Kyoto was built as an aristocratic retreat but was soon after transformed into a Buddhist temple. But whether villa or temple, the Phoenix Hall's interiors were designed to interact with its surrounding gardens. With long *engawa*-like corridors, garden and house/temple are inseparable.

Modern takes on the *engawa* find their way into many contemporary house designs. Uemachi Laboratory's House in Nara (page 42) and Takashi Okuno's House in Nagahama (page 84) offer contemporary versions of a Shoin/Sukiya-style engagement between house and garden via *engawa*-like corridors, along with modern terrace space for relaxing, eating or barbequing. Edward Suzuki's House of Maple Leaves (page 94) creates two levels of crisply defined sheltered balconies that echo the *engawa* concept. A more traditional *engawa*, such as in the renovated Shinmachi House in Kyoto (page 182), can be used in a modern context as a place for summer evening drinks or morning tea next to the tiny but charming urban garden.

In space-challenged Japan, Tezuka Architects even created an 'Engawa House' (http://www.tezuka-arch.com/japanese/works/engawa/05.html). Taking the shape of its small, long, narrow site, the house is basically an elegant extended corridor with one side of glass doors that open to turn the entire home into an *engawa* in fine weather. Produced in many sizes, materials and traditional or modern detail, the concept of the *engawa* is endlessly adaptable in, or even as, the contemporary home.

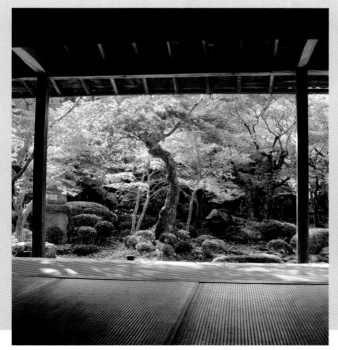

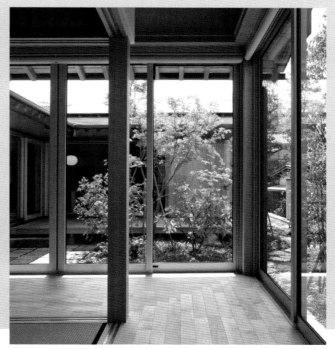

REINVENTING TRADITION
TOWARDS A MORE SUSTAINABLE FUTURE

Shoji and *fusuma* screens, *sudare* bamboo window blinds, *tatami* matting, passive heating and cooling principles, building with natural/renewable/ recyclable materials, building a house in relation to its natural setting as well as in relation to the family life lived within it—these are all centuries-old traditions of Japanese house design. Largely cast aside in the twentieth-century rush to build and modernize, these fundamentals are now being reassessed and reapplied in contemporary house design. This chapter presents projects that have embraced and adapted tradition, blending the best of old Japanese design into the houses of the future.

The passive energy principles of the seventeenth-century Katsura Imperial Villa are the inspiration for Edward Suzuki's elegant House of Maple Leaves. Kengo Kuma explores the cold climate architectural traditions of the Ainu people in Même Meadows on the northern island of Hokkaido. Key Architect's Kotoboshikan blends the natural passive energy qualities of traditional Japanese building materials in a house based on modern PassivHaus technology. In the Mini Step House, Lambiasi + Hayashi create a home for a young family based on the sensibilities of a rural Japanese house. Takashi Okuno's House of Nagahama in Shikoku updates the traditional integration of house and garden. Each house evinces a smart energy design, a sensible approach to materials and a mix of Japanese traditions and contemporary living.

HOUSE IN NAGAHAMA

ARCHITECT **TAKASHI OKUNO ARCHITECTURAL DESIGN OFFICE**

LOCATION **NAGAHAMA, EHIME PREFECTURE**

COMPLETION **2014**

The desire for the new has been a driving force in architecture in Japan for much of the twentieth century. Traditional house architecture was often considered out of date and inconvenient. An old wooden house simply could not be the setting for a modern lifestyle. However, tastes are changing as a younger generation who have grown up in complete modernity find they have a desire for the old.

High-tech educated young architects are looking more to their architectural past to find solutions for modern problems, from unsustainable building practices to a built environment of concrete and neon. "My concept is to make Japan a more beautiful place to live in," explains Matsuyama-based

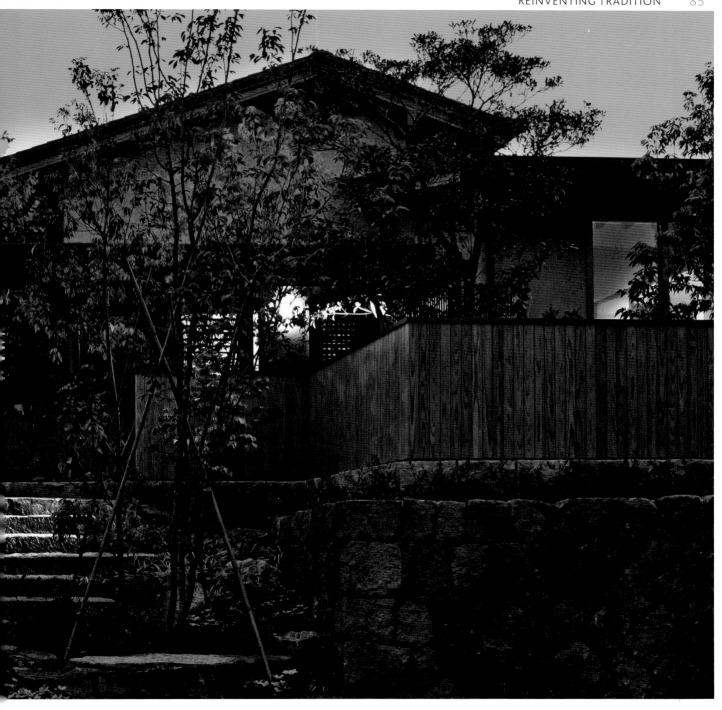

Previous spread A path of flag-
stones embedded in grassy soil
leads up to the entrance, sheltered
under a deep timber eave.
Left The house is centered on a
family living room with broad glass
sliding doors opening onto the
garden courtyard.

architect Takashi Okuno. "We build
beautiful Japanese houses with the best
materials for the local climate."

In Okuno's House in Nagahama, the
modern and the traditional blend seam-
lessly in a new single-story residence.
Located in a small town in Ehime prefecture
on the island of Shikoku, the house takes
advantage of its generous 225-square-
meter plot. The building itself covers less
than a third of the building site, leaving
plenty of room for green space. Thus, trees
and small gardens fit into the spaces
between rooms. The plan features four
asymmetrical spaces radiating from a
central square, each opening up to a
different outdoor space. Okuno explained:

"Taking advantage of the spacious site,
I placed five gardens, each one with a
different atmosphere, which are all
designed to ensure privacy."

The elegant simplicity of the woodwork
recalls the traditional temple architecture
of Shikoku, an island famous for an
88-temple Buddhist pilgrimage route.
Fine craftsmanship throughout the house
recalls a long carpentry tradition. The
building is entered via the *maeniwa*, a
traditional garden entrance. A path of
flagstones embedded in the grassy soil
leads to a sliding door entrance sheltered
by a deep timber eave with exposed
structural framework. The woodwork
echoes the long Japanese tradition of

design of the house, including contemporary leather armchairs and sofa, and a wooden dining table surrounded by Danish designer Hans J Wegner's iconic Wishbone Chairs. Okuno's design embodies a functional beauty grounded in the Japanese past and balancing contemporary needs with an eye to the future.

PASSIVE DESIGN
GREEN SPACE
NEIGHBORHOOD FRIENDLY
TRADITIONAL ECO MATERIALS AND CRAFTSMANSHIP

Right above and below The master bedroom opens onto its own west-facing garden. A contemporary sliding *shoji* screen offers privacy as well as a choice between subdued lighting or a garden view.

Below The wet room bathroom and washbasin area are divided into two spaces, both looking onto a private north-facing terrace.

Right A traditional Japanese-style room has an *engawa* (elevated terrace) facing the garden.

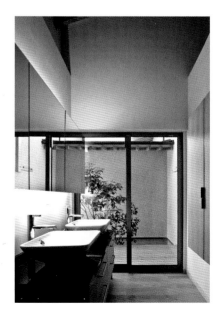

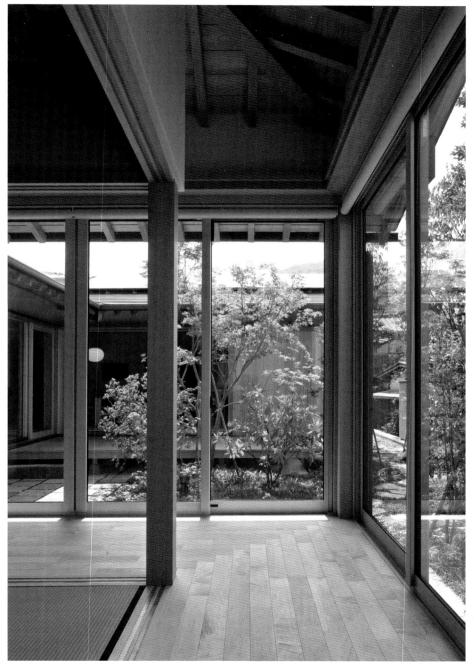

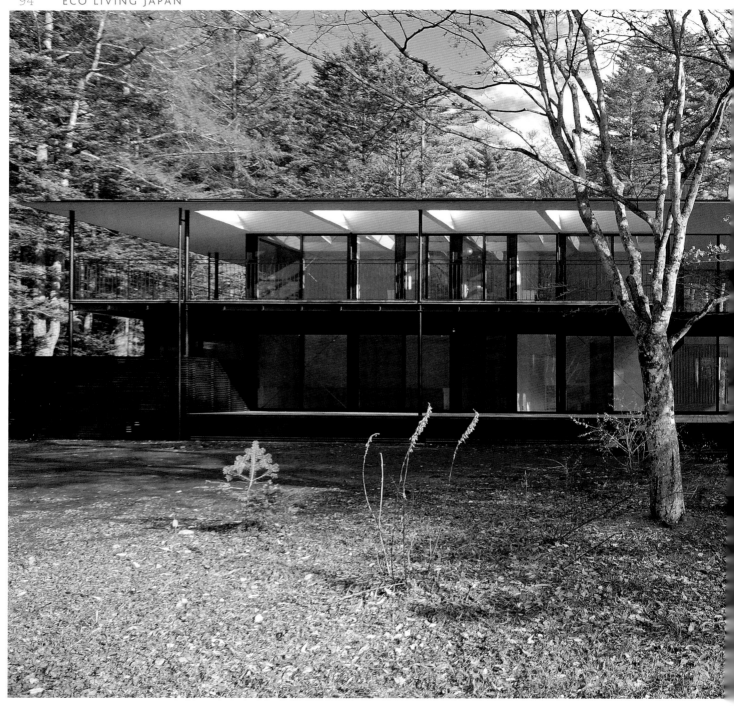

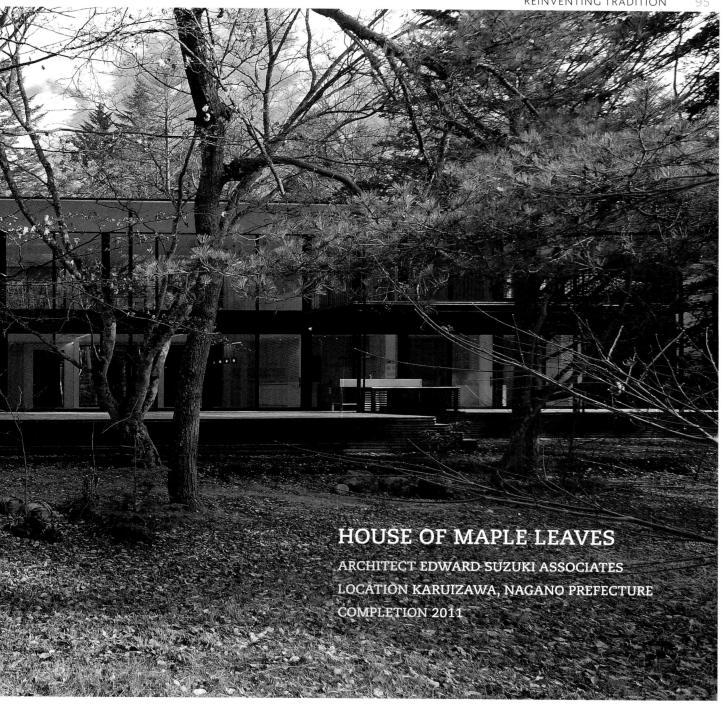

HOUSE OF MAPLE LEAVES

ARCHITECT EDWARD SUZUKI ASSOCIATES

LOCATION KARUIZAWA, NAGANO PREFECTURE

COMPLETION 2011

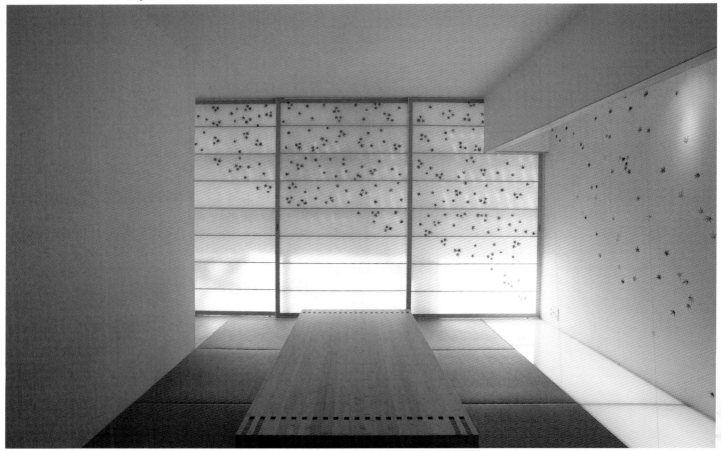

meters of living space over two levels. Yet, the wooden structure, with peripheral steel balconies, sits snugly on the ground. Its exterior façades are covered with broad glazed openings. The rear façade is, in fact, composed almost entirely of windows. Taking its cue from the Japanese concept of *shakkei* or 'borrowed landscape', the concept of making the landscape part of the visual experience of the interior, the House of Maple Leaves takes its name literally, borrowing the landscape to beautify every room in the house. Inside, *shoji* screen partitions create fluid interior spaces. Even when the *shoji* screens are closed, maple leaf patterns can be seen dappled across their paper surfaces.

Despite its luxurious size, the villa's crisp overall design echoes the harmonious simplicity and naturally passive energy principles of Katsura Imperial Villa's traditional Shoin/Sukiya architecture. Cross-ventilation under the ground floor protects against humidity, while good

Above Even when the *shoji* screens are closed to the natural views, maple leaf patterns can be seen dappled across their paper surfaces.

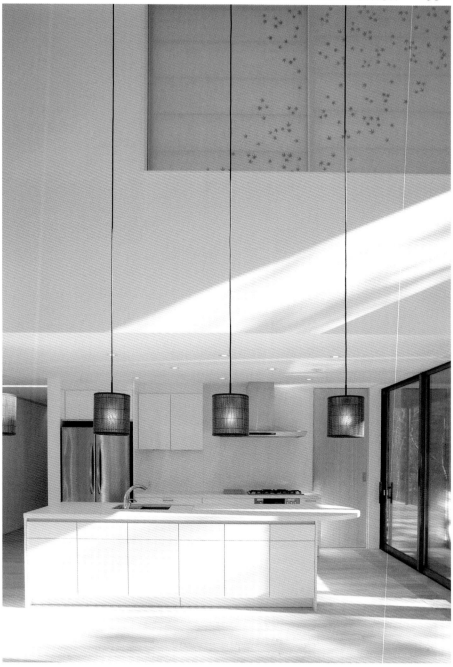

Right The open kitchen looks onto the double-height living and dining area.
Above Delicate paper screens echo the theme of the House of Maple Leaves.

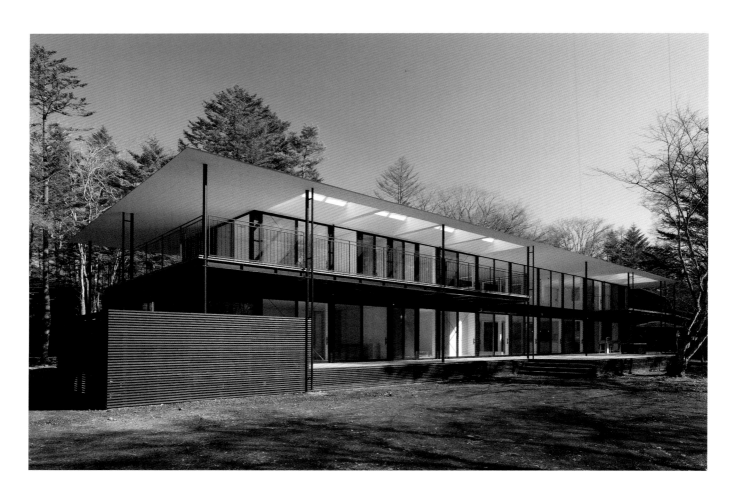

Above The rear façade is composed almost entirely of operable windows, which open to terraces shaded by broad eaves. **Opposite** Openings are placed for cross-ventilation, limiting the need for air-conditioning.

exterior insulation and broad double-pane windows with airtight, high-insulation sashes help to effectively cool and heat. The glazed walls and reflective silver roofing act as passive solar collectors working with the fireplace and radiant hot water heating embedded in the floor, the only active operating system in the house, to warm the house in cold weather. Deep, flat overhanging eaves block the hot summer sun but allow the low light of winter into the house. The garden's deciduous trees function similarly, dappling light in summer and maximizing it in winter. Windows are placed for cross-ventilation, limiting the need for air-conditioning. The lights are

Previous spread The distinctive origami-like roof is meant to echo a *hokkamuri*, a traditional head covering used in local agriculture. **Left** The ground floor features an open living/dining/kitchen plan with broad double-paned sliding doors.

The project was a unique collaboration between the local community and an avant-garde architect trained in Europe with a wish to bring more sustainable building practices to her native country. In just a few years, Miwa Mori of Key Architects has won over numerous clients and builders to the practical sustainability of German-Passive House design (see page 138). Adapting the concept to the Japanese environment, Mori aims to construct houses that act and react according to the local climate, using the latest technology and materials with natural thermal and insulation qualities that help reduce moisture in high humidity, a major issue in Japanese houses, and conserve heat in cold weather.

For this project, she convinced the mayor of Totsukawa and ten residents to travel with her to Germany to learn about Passive Houses. The result was Kotoboshikan, a model Passive House in Totsukawa village, built by local builders with local materials mixed together with high-tech passive house technology.

The house is a contemporary family residence spread over two floors with 178 square meters of living space. The ground floor features an open living/dining/kitchen plan linked to the upper bedrooms and play area by an open staircase and a wood burning stove that reaches from floor to ceiling and helps to warm the entire well-insulated structure in winter.

Local cedar is used in the interior and exterior as both structural and decorative elements. The distinctive origami-like roof is meant to echo a *hokkamuri*, a traditional head covering used in local agriculture. The form is both functional, forming a pitched roof with deep shading eaves, and a sign of respect to local traditions: "I wanted to create a design that fit into the area, not an imported idea of urbanism but a form that reflected local traditions," explained Mori.

Passive House regulations demand a house have an airtight building shell to control humidity and store heat energy. Mori employed a traditional Japanese wall-building technique using a bamboo framework and *tsuchi-kabe*, or waddle-

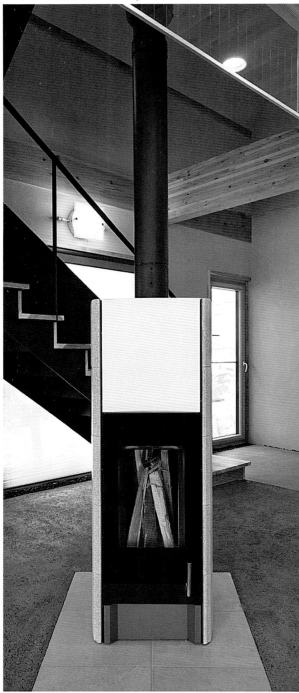

Left The two floors of the family residence are linked by an open staircase and a wood burning stove that reach from floor to ceiling.
Right Local Totsukawa wood and opaque natural light create inviting interior spaces.

MÊME MEADOWS

ARCHITECT KENGO KUMA AND ASSOCIATES—KENGO KUMA AND TAKUMI SAIKAWA

LOCATION HIROGUN, HOKKAIDO

COMPLETION 2011

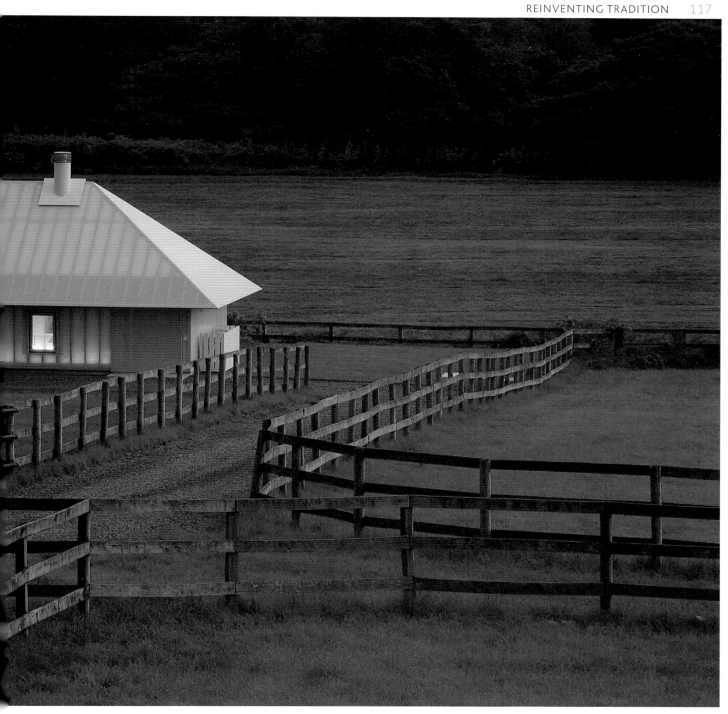

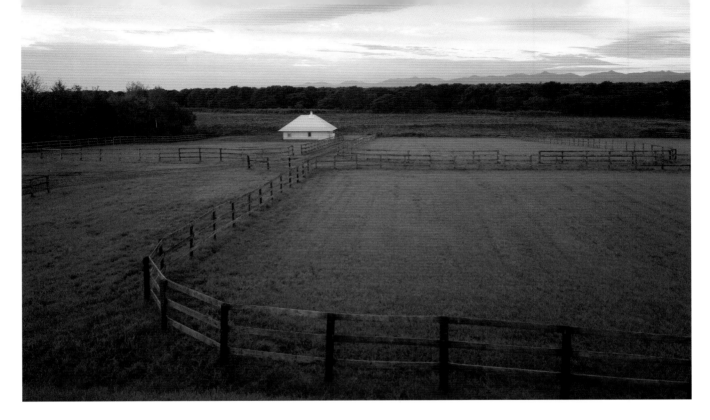

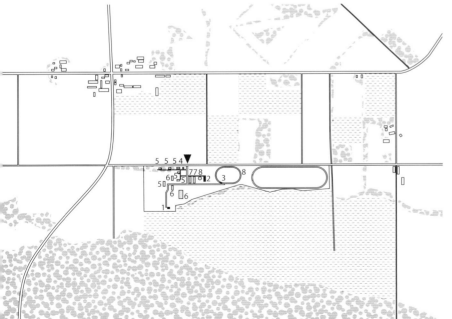

One of architecture's basic functions is to cope with climate. This is true of both historic and modern structures. In recent years, the hard-won wisdom of traditional architecture is being reconsidered by contemporary architects as they move towards building more sustainability. Kengo Kuma is a well-known proponent of using the best of historic architecture in contemporary design. In Même Meadows, an experimental house in rural Hokkaido, the northernmost island of Japan, he combines the traditions of the native Ainu people with the latest technology to find new ways of designing sustainable homes.

Previous spread The experimental Même Meadows draws on the traditional residential architecture of the Ainu.

Opposite above The experimental house is set in a rural area of Hokkaido, the northernmost island of Japan.

Opposite below Layout of the Centre for Research of Environmental Technologies, located on a former horse breeding farm. Même Meadows is no. 1.

Below The high-tech rectilinear profile of the house nestled in snow.

Kengu Kuma and Associates teamed up with the Memu Meadows Centre for Research of Environmental Technologies, which aims to improve lives through the development of new eco-minded concepts, to discover innovative residential design solutions for extreme climatic conditions. Hokkaido is known for its cool, dry summers and icy winters, and thus its traditional architecture is distinct from that of mainland Honshu where winters are mild and summers hot and humid. The Ainu, the

first inhabitants of Hokkaido, created their own form of domestic architecture, called the *chise*, which literally translates as 'house' but is also suggestive of 'welcome'. Its main materials were grass and earth, with thick layers of soil and dried grass as thermal insulation and a central, never-extinguished fire pit that radiated heat.

In the design for the Même Meadows house, the architects aimed to create the same type of thermal qualities in a highly contemporary design. As if wanting to

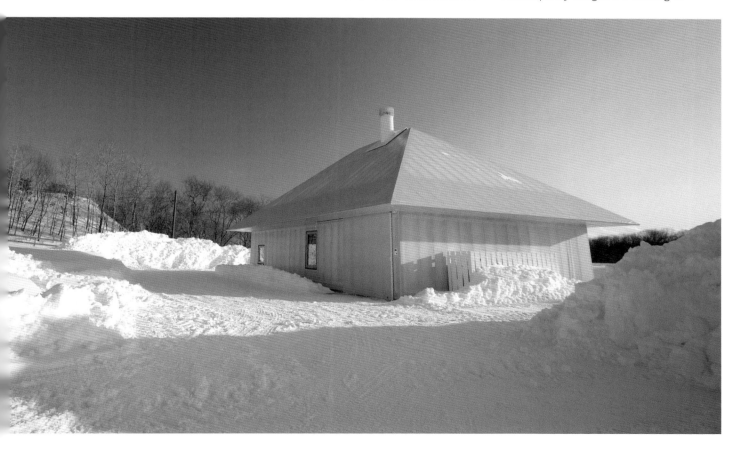

Right The design is inspired by Ainu *chise*-style buildings, which hold in the warmth of an ever-burning central fireplace.

Below The house's Japanese larch frame is covered with a thick layer of polyester insulation sand-wiched between exterior polycarbonate cladding and interior glass fiber fabric.

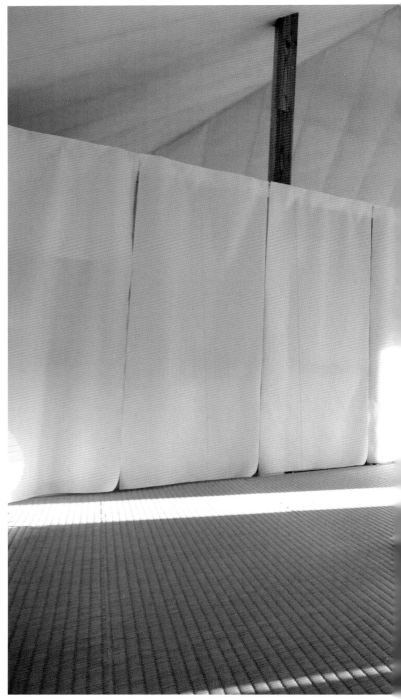

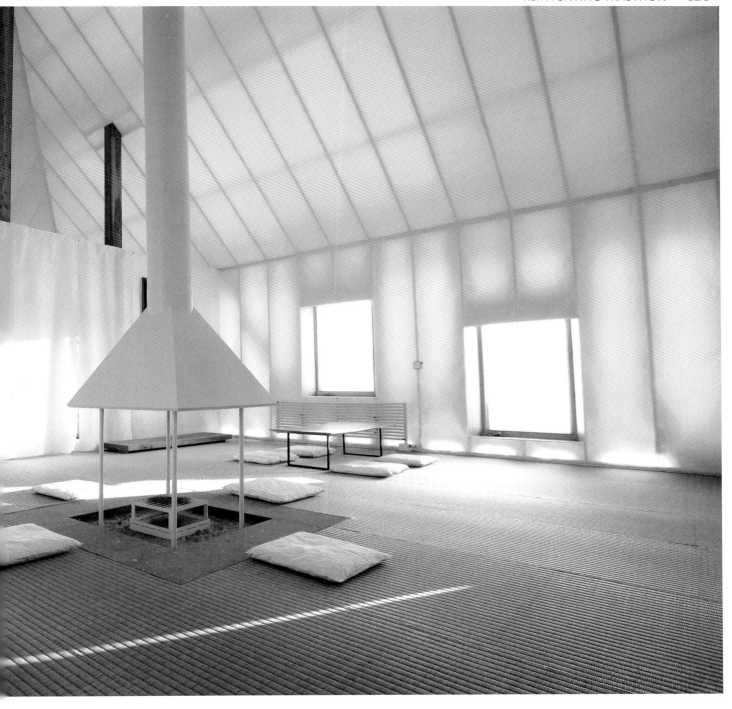

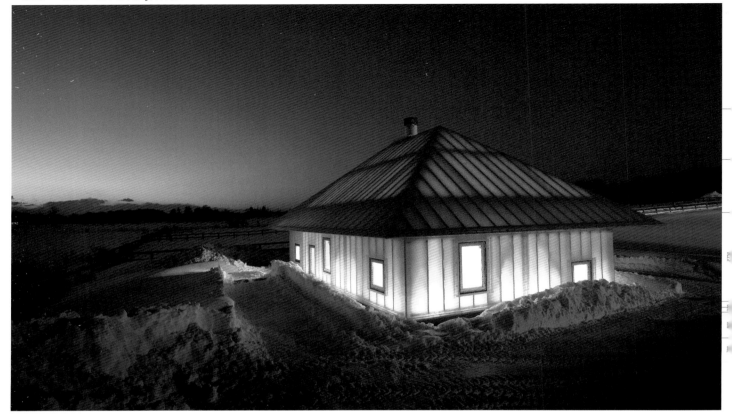

create the greatest challenge possible in a snowy climate, they decided to make the house translucent. By mixing hi-tech materials and traditional know-how, they were able to produce an energy-efficient contemporary Ainu *chise* that would not look out of place on the cover of the latest house design magazine, where, in fact, Même Meadows has been featured.

The overall design principle focused on the layering of materials. The main structure was made of local larch and is clad in three translucent layers: an outer skin of fluorocarbon-coated polyester fabric, an insulation layer of thermal polyester fiber made from recycled PET bottles, and an inner skin of glass fiber fabric. The coated fabrics provide protection from the elements and allow air to circulate between the layers, creating a convection effect, thus adding warmth in winter. The snowy white texture of the materials function in rhythm with the natural patterns of light and season. In daylight, the house is filled with warm natural light, which fades as evening falls, and at night the lit house glows like a simply drawn paper lantern. In cold weather, the continuously burning central hearth warms the ground, whose thermal mass radiates heat day and night. Windows are placed at irregular intervals and offer cross breezes in the brief summer months.

The interior is laid out as a large studio, with the living/dining/kitchen separated from the bedroom by removable cloth partitions, which function much like *shoji* screens do in traditional Japanese house design in more southern Japan. *Tatami* mats cover the floors, and a full bathroom with concrete floors, a material that also offers a natural thermal mass, sits behind a glass

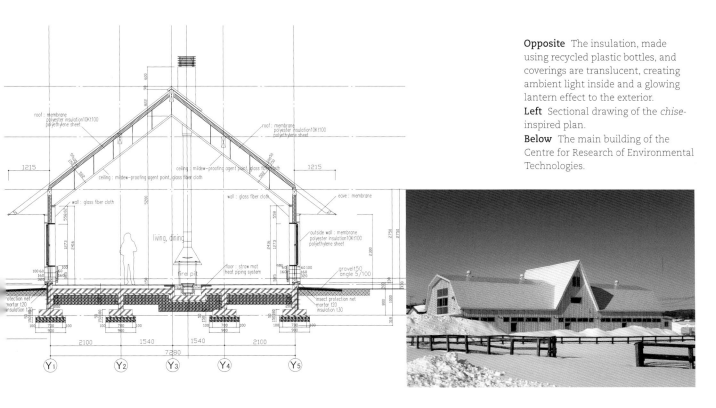

Opposite The insulation, made using recycled plastic bottles, and coverings are translucent, creating ambient light inside and a glowing lantern effect to the exterior.
Left Sectional drawing of the *chise*-inspired plan.
Below The main building of the Centre for Research of Environmental Technologies.

partition. The layout reflects the openness of domestic space of much traditional Japanese architecture. Public and private spaces are adaptable and vary according to need with the help of removable partitions.

Other elements are also changeable, such as the removable inner layer of glass fiber fabric and a wooden window sash, all part of Kuma's ongoing experiments with "dynamic environmental engineering". Kuma has a fine reputation for his sensitive approach to environment and context and often works with local materials to "resolve the architecture in its environment". Here,

he pushes his own boundaries with new materials used in authentic traditional ways to modern, energy-efficient ends. The synthesis utilizes the latest technology but maintains a human scale, deeply linking the occupants with the local environment.

TRADITIONAL ECO TECHNOLOGY
PASSIVE HEATING TECHNIQUES
ENERGY EFFICIENT
CONNECTION TO NATURAL SURROUNDINGS

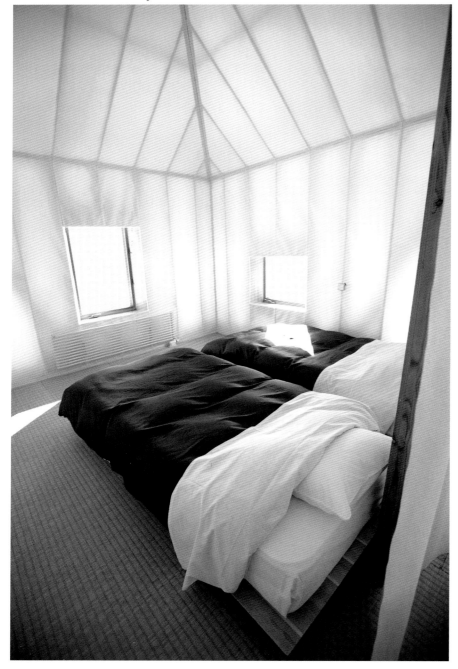

Left The bedroom area by a curtain wall.
Below In the bathroom, pipes under the floor filled with hot water help to generate heat.

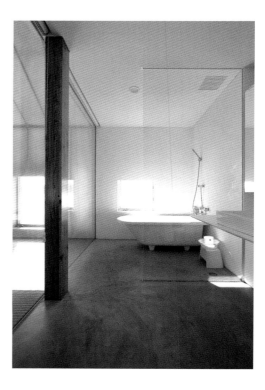

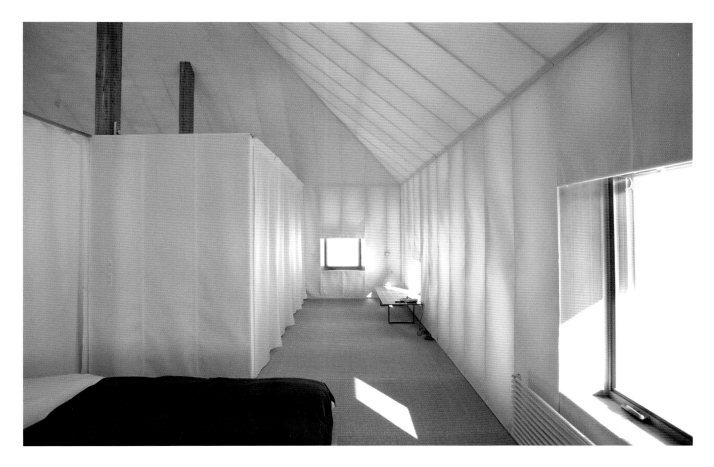

Above The house is minimally partitioned
with just a few dividing curtain walls.
Right The open space allows air convection
currents from the fireplace and floor to
radiate and easily warm the house.

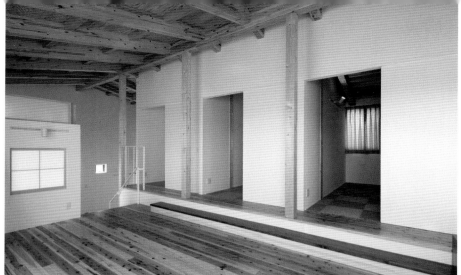

Opposite Wooden steps leading up past a *tatami*-matted room to the living area.
Left Bedrooms open onto the living area.
Below The interior maintains a harmonious palette of golden wood and pure whites.

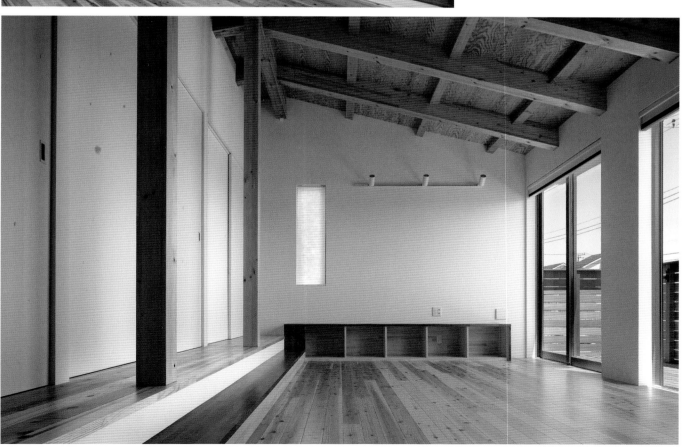

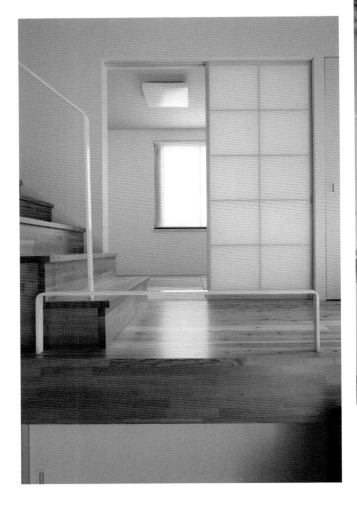

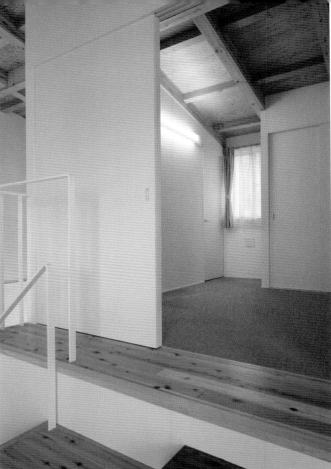

Above left Translucent *shoji* sliding doors
create elegant partitions.
Above right Solid *fusuma* sliding doors
offer complete privacy in the bedrooms.

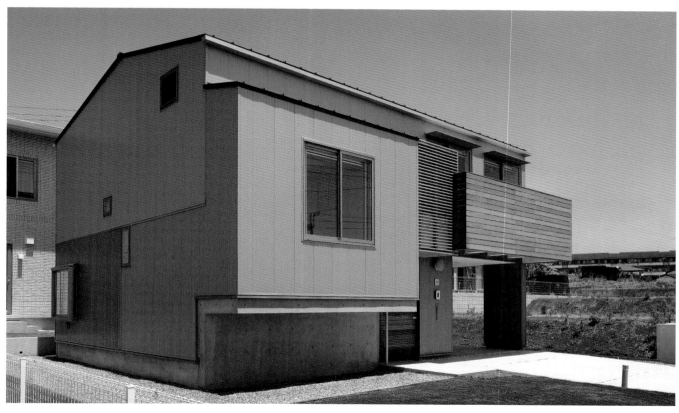

Above The house is set at the rear of the plot to allow for a family vegetable garden in front.
Right Varied tinted metal cladding creates a lively exterior and suggests the sophisticated design inside.

KATSURA IMPERIAL VILLA
A SEVENTEENTH-CENTURY STANDARD FOR MODERNITY

After visiting the Katsura Imperial Villa in Kyoto in 1933, German architect Bruno Taut made a remarkable statement: "Japanese architecture", he said, "has always been modern." The villa, an early seventeenth-century princely retreat whose design was inspired by an eleventh-century Japanese literary classic, *The Tale of Genji*, would not seem an obvious example of Modernism. Yet, laying in faded, semi-forgotten splendor along the Katsura River, the structure spoke to early twentieth-century architects as a pre-modern version of their search for pure, functional design. Taut lauded Katsura's clean lines, harmonious simplicity and innate modernity. Soon after, Walter Gropius and Le Corbusier, two of the most influential figures in twentieth-century architecture, would visit Katsura and be similarly impressed. Wrote Gropius to Le Corbusier: "All what we have been fighting for has its parallel in old Japanese culture.... The Japanese house is the best and most modern that I know of...."

So why was an early Edo-era villa made of wood and paper suddenly the height of global architectural modernity?

To Modernist eyes, the traditional architecture of Katsura seemed sort of pre-concrete proto-Modernism. Its crisp modular design fit easily into the idealized functionalism of early twentieth-century architecture. Yet, beneath the Modernist's vision was a long, layered history of Japanese residential design and craftsmanship.

Katsura Imperial Villa was created by the greatest craftsmen of the day of the finest materials available, which were, of course, all natural, renewable and recyclable: wood, paper, reed, etc. The seventeeth-century builders drew on traditions of aristocratic Shoin-style residential architecture dating back to the Heian period (794–1185), updating it with the understated elegance of contemporary teahouse aesthetics, defining the Sukiya/Shoin style. It is a style of contrasts and delicate tensions, at once subdued and unostentatious. It also evinces a meticulous attention to detail, creating a precise and elegant air of informality.

The main structure is a traditional wooden post-and-lintel construction with pitched roofs and removable screens and partitions, creating flexible interiors. The layout of house and garden is asymmetrical, leading to unexpected spaces and vistas. Architecture, landscape and gardens are intimately connected with a deft intertwining of natural materials, diverse textures and subtle hues. The concept of *shakkei*, or 'borrowed landscape', finds full expression in Katsura with every opening offering lyrical views of its vast gardens dotted with lanterns leading to rustic teahouses, an artificial pond and 112 varieties of trees. A simple bamboo platform is perhaps its most poetic element. Called the 'moon-viewing balcony', it was designed as a space to contemplate the full autumn moon.

Katsura today attracts thousands of international visitors annually despite the need to make a reservation for a guided tour (in Japanese only) months in advance. Its simple grace and architectural expression of the possible unity of the natural and the man-made, form and function, would seem to only improve with age.

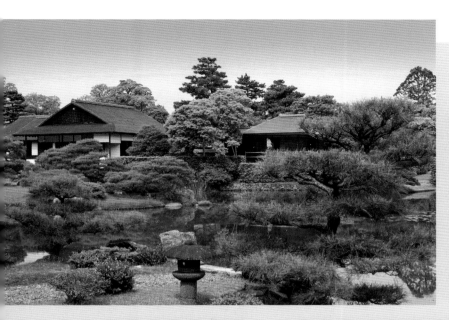

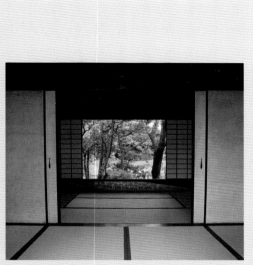

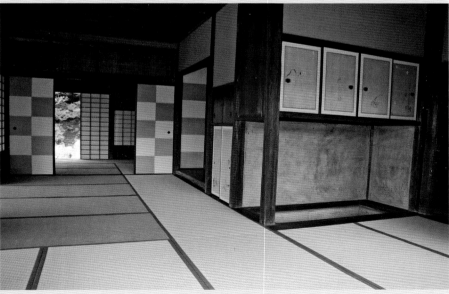

Top left Katsura Imperial Villa in summer.
Top right *Fusuma* sliding doors allow 'borrowed landscapes' inside.
Bottom left Bamboo latticework.
Botton right The play of color, pattern and texture in the interiors.

PASSIVE QUALITIES
THE NATURALLY PASSIVE QUALITIES FOR KEEPING THE TRADITIONAL JAPANESE HOUSE COOL

In our cities of glass and concrete, heating and air-conditioning systems are de rigueur. But how did we regulate temperature in our homes before electricity? How did Japan, infamous for its *mushiatsui* (hot, humid) summer weather, keep cool?

The first and most obvious step lay in the design. Traditional houses in much of Japan were designed to deal foremost with summer. Houses were oriented and openings strategically placed to make best use of sunlight year round, creating maximum shade in summer and letting in low winter light. Houses were built with natural cooling properties: deep eaves for shade, wide openings for natural air circulation and freshening gardens. Houses were often raised off the ground on pillars to allow for under-floor air circulation. Gardens and wooden surfaces absorb rainwater, which then evaporates, creating a cooling effect. Today, water is still sprinkled on streets and balconies in hot weather to naturally cool the air.

Modulating sunlight was vital. Porous barriers were developed that could be altered with the varying seasons. Trees and trellises with lush summertime growth were strategically placed to block the worst of the solar heat yet allow dappled daylight to illuminate interiors. Similarly, removable *sudare* (roll-up bamboo screens) were hung outside openings, allowing only a gentle diffused light into interiors. Interior movable and removable *fusuma* (solid sliding screens) and *shoji* (opaque sliding screens) created gradations of light and shadow, depending on the weather and season.

The choice of materials also helped. Modern materials like concrete and glass hold and radiate heat but natural materials, such as wood, earth and reeds, are more adaptable. *Tatami* mats and earthen walls absorb moisture when humidity is high and release it when dry.

While many of these basic principles were often overlooked in modern construction, many homeowners and designers in Japan are now returning to these simple strategies in both traditional and highly modern homes for natural temperature regulation and the energy savings that result.

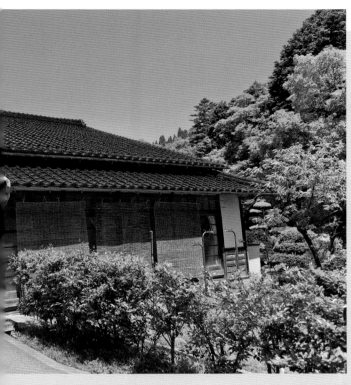

Above Deep eaves create shade, while natural materials help mitigate heat and humidity.

Left *Sudare* screens block full sunlight from reaching interiors.

Below left A traditional house raised off the ground and surrounded by greenery.

Below *Tatami* mats and *shoji* screens help to moderate temperature and light.

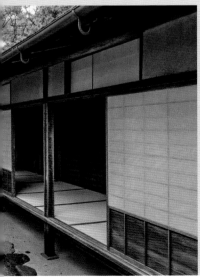

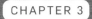

'SMART' GREEN
INNOVATION, TECHNOLOGY AND SUSTAINABILITY

Houses can be fertile ground for sustainable experiments. Small, self-contained, often with progressive-thinking clients, house projects in Japan frequently push boundaries.

Sustainability is now an issue for most architects, yet theory and talk don't always lead to practice. Terms like 'green', 'eco' and 'sustainable' are sometimes used more as marketing and public relations tools than in actual construction practice. Cost, regulations and even an architect's search for a 'pure' design, with functionality and sustainability as secondary issues, if considered at all, can get in the way. True sustainability remains rare, which is why the projects featured here stand out.

This section looks at 'smart' houses, 'smart' meaning projects that aim to make the home as environmentally friendly and resource-efficient as possible through innovative high-tech and low-tech design, low-energy consuming materials or simply by a more sensitive approach to material, place and function. These projects all put their sustainable words into action.

Key Architects' Passive House in the alpine resort of Karuizawa uses German Passive House technology to create what has been called the most energy-efficient house in Japan. Bakoko's flexible Onjuku Beach House is a building designed with people in mind, responsive to the needs of its inhabitants and its surroundings. The A-Ring House is part of a series of experiments by Atelier Tekuto with aluminum to create sustainable, energy-efficient housing.

PASSIVE HOUSE KARUIZAWA

ARCHITECT KEY ARCHITECTS
LOCATION KARUIZAWA, NAGANO PREFECTURE
COMPLETION 2012

The stylish alpine town of Karuizawa, about 60 minutes by bullet train from Tokyo, is no stranger to design architecture. But this distinctive house has attracted attention not only for its good looks but also for its substance. It has been called the most energy-efficient house in Japan and, according to its owners, it is also one of the most functional and comfortable.

The house is also a particular favorite of its architect, Miwa Mori, founder of Key Architects and representative of Passive House Japan (see page 149). After her architecture studies in Japan, Mori spent ten years studying and working in Europe, first in Germany and later in Ireland. She became a certified Passive House designer in 2010. Returning to Japan, Mori brought with her a uniquely international set of skills and a desire to bring the sustainable practices of traditional Japanese architecture into the twenty-first century by applying Passive House ideas and technologies in a contemporary Japanese context.

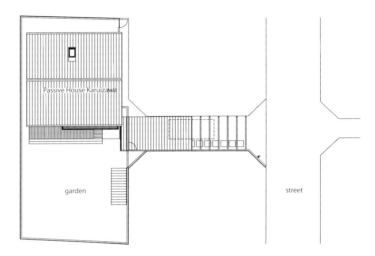

Previous spread The house's exterior is black galvanized steel, which recalls traditional charred wood techniques, accented with natural wood.

Passive House Karuizawa

garden

street

"If we evaluate each component of Japanese traditional architecture, it makes sense in the context of the past," explained Mori. "But now we need to reevaluate each aspect in a modern context, in relation to technology…. In the past, we have thought it could not go together, and old houses were just torn down and replaced. But we can rethink this relationship and build better houses that can last a hundred years."

Passive House Karuizawa is Key Architects' third certified Passive House in Japan. The energy-efficient design offers an alternative to the practices of Japan's dominant building industry.

Germany's Passive House design demands that a house be well insulated, well constructed and affordable to maintain a comfortable temperature all year round, eliminating the need for active heating and cooling systems. At its simplest, a twenty-first century Passive House is about the efficient use of natural resources, which is the same basic principle of the traditional Japanese house.

Japanese traditional houses employed natural and recyclable materials, south-facing windows, deep overhangs, clay walls to supply thermal mass and help manage humidity, and sliding screens for natural ventilation. This, however, is not the case

in most contemporary Japanese houses. Built with non-recyclable materials, thin walls and single-pane windows, inefficient attention to moisture issues, and with no intention of lasting more than a generation, if that, contemporary house design is in many ways its polar opposite. Heating in winter and cooling in summer is energy-intensive and expensive.

For the Passive House in Karuizawa, the aim was to achieve a comfortable balance between humid summer and snowy winter using Passive House principles in a Japanese setting, which meant adhering to strict seismic codes and dealing with the damp climate.

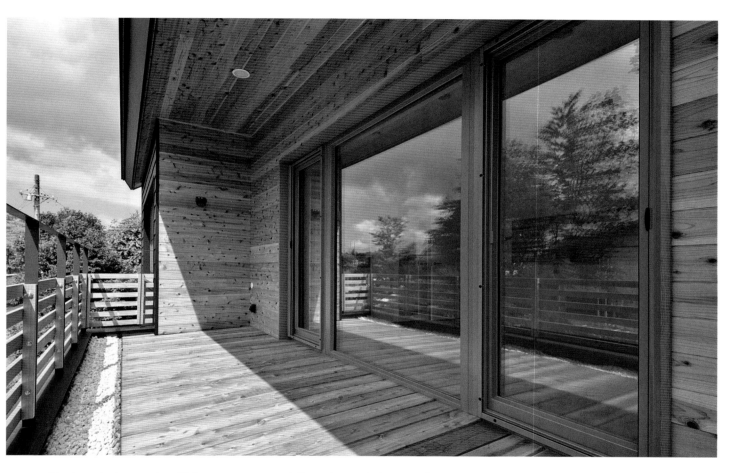

The footprint is a succinct 83.9 square meters with 168.14 square meters of living space spread over two floors. The exterior is black galvanized steel, which recalls traditional charred wood techniques, accented with natural wood, and is insulated with wool and foil to create a moisture seal and prevent the build-up of mold. Windows are triple-paned with specially made wood-aluminum frames to prevent heat loss. Inside, a north-facing skylight acts like a chimney, drawing out excess heat. In-floor heating is installed, but such is the efficiency of the house's design that it has yet to be used. With the use of a heat recovery generator, the temperature is constant and the air fresh year round. The house is, in fact, energy positive and sells

Opposite left The sheltered entry with a louvered wooden wall.
Opposite right The footprint is a compact 83.9 square meters with 168.14 square meters of living space spread over two floors.
Above Customized triple-pane windows work with walls insulated with wool and foil to create a moisture seal.

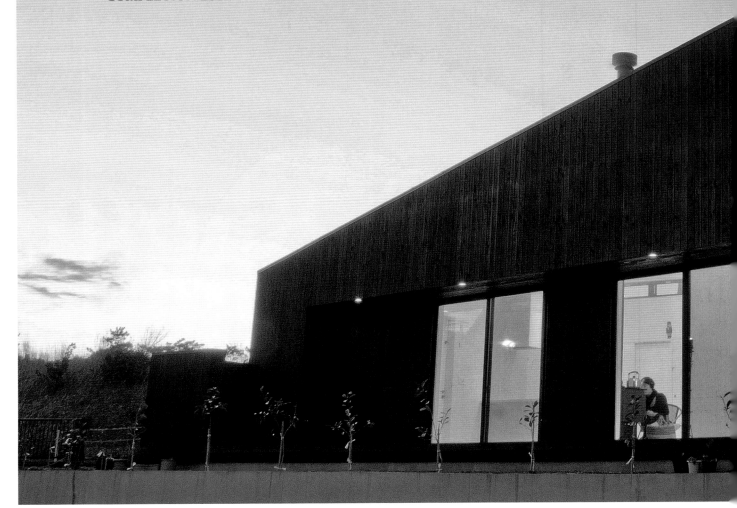

ONJUKU BEACH HOUSE

ARCHITECT **BAKOKO ARCHITECTS**

LOCATION **ONJUKU, CHIBA PREFECTURE**

COMPLETION **2012**

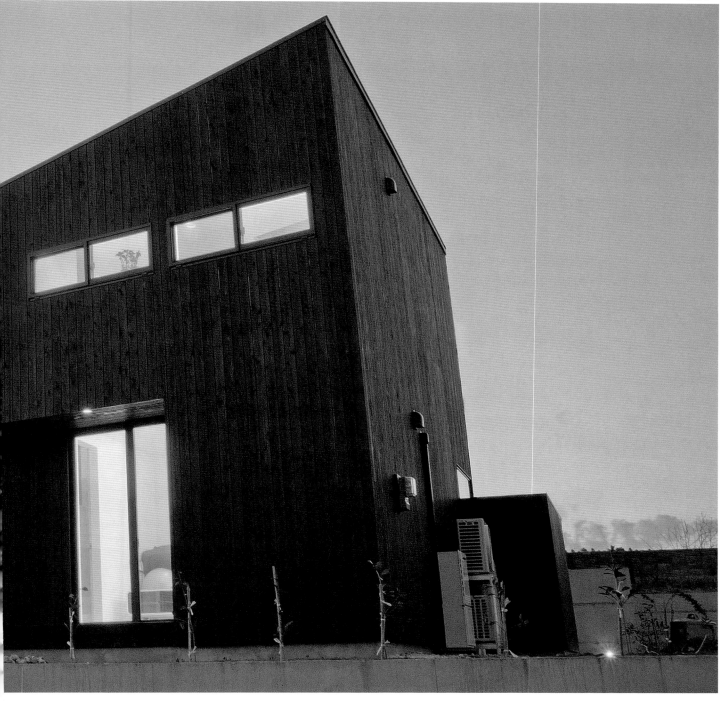

shoes removed. Being a surfer house, there is also a shed for surfboards and bikes, accessible from both the exterior car park and at the end of the passageway.

The smoky black exterior opens into a pleasingly light interior of finely worked pale spruce and clean whitewash. Interior space is organized around a double-height living and kitchen/dining area, which opens onto the long sheltered deck. The long room's glazed sliding doors act as a porous and flexible line between interior and exterior, altering with the season and mood.

A wood-lined study is concealed by carefully crafted folding, sliding wood doors that blend into the wall when closed. The study forms part of a similarly spruce-clad box that supports a second level loft space

Above left Sculptural stairs and a discreet door leading to the master bedroom.
Above right A hobby room of pale spruce sits just off the living area.

Right Upper floor living space with a built-in desk and ladder leading to the roof.

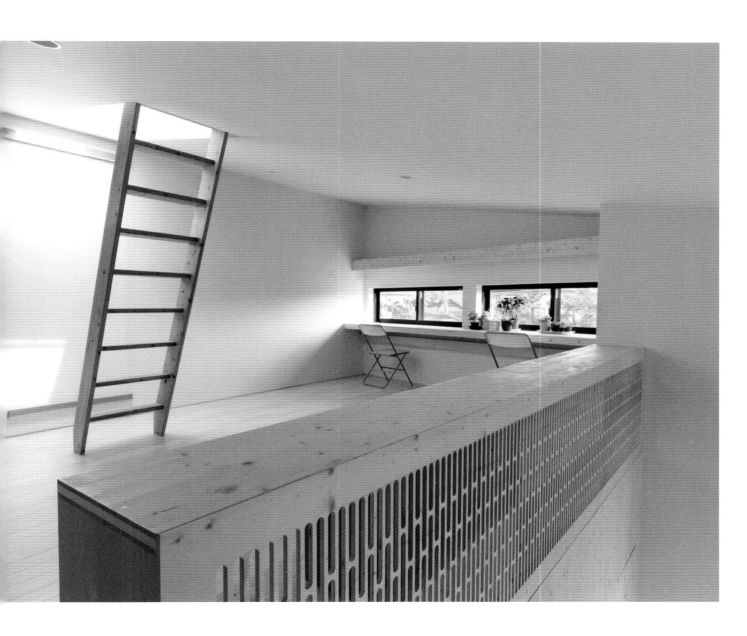

reached by a sculptural staircase. Below, a discreet door leads to the master bedroom, toilet and bathroom. The loft space features built-in desk space overlooking the sea as well as an opening skylight and ladder that leads up onto the low-pitched roof. The loft spaces and the enclosed study can also double as occasional sleeping quarters for guests.

A north side entrance leads into a uniquely surfer feature: a private outdoor shower for a post-surfing rinse that, in turn, leads directly into the main bathroom. The white-tiled room features a sunken bathtub and a window overlooking a small walled garden.

Considering the owners' wishes and lifestyle, the suburban seaside setting and environmental concerns, the architects have come up with a compact, flexible and functional living space with a small footprint and good passive solar design. Importantly, it is also a neighborhood-friendly house: distinctive yet unobtrusive, offering privacy yet ready to open to its environment and neighbors when the surf is up.

PASSIVE SOLAR DESIGN
SMALL FOOTPRINT
RECYCLABLE MATERIALS
NEIGHBORHOOD FRIENDLY
SENSITIVE APPROACH TO SETTING AND MATERIALS

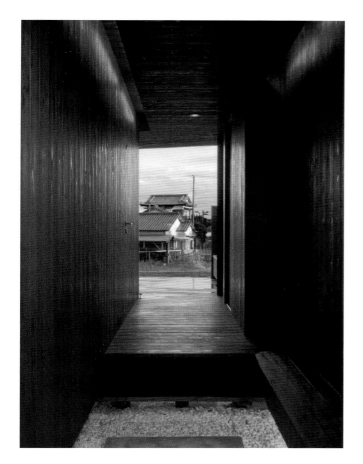

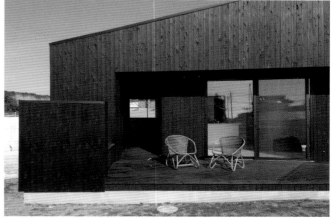

Opposite A north side entrance leads into a uniquely surfer feature: a private outdoor shower.

Above The main entrance is discreetly placed to the left of the long façade and functions as a characteristically Japanese *genkan*.

Above right A sunken bathtub with a window overlooking a small walled garden.

Right The design creates a compact yet flexible and functional living space both inside and out.

A-RING HOUSE

ARCHITECTS ATELIER TEKUTO AND THE KANAZAWA
INSTITUTE OF TECHNOLOGY

LOCATION KANAZAWA PREFECTURE

COMPLETION 2009

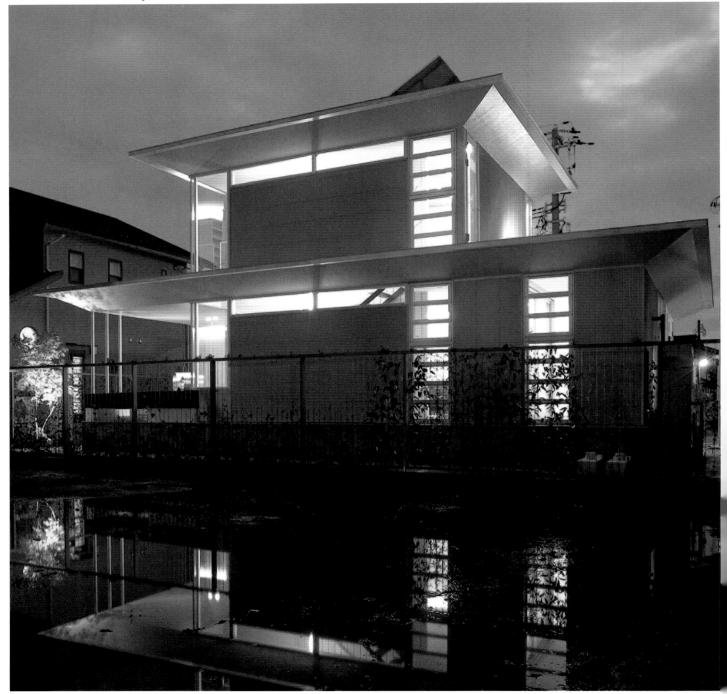

Previous spread Deep
projecting eaves on both levels
provide shade.
Opposite The prefabricated
house's windows are placed
with the seasons in mind,
maximizing light and warmth
in winter and reducing them in
summer.
Left The A-Ring House employs
aluminum 'rings', actually
square aluminum frames joined
together to form floors, walls
and ceilings.

Although environmental sensitivity, close attention to materials and sustainability were low priorities during the rush for modernization in the second half of the twentieth century, they are integral to traditional Japanese architecture. These qualities are once again becoming important in the work of a new generation of architects. The A-Ring House (Aluminum-Ring House 3) is the third in a series of experiments by Atelier Tekuto using aluminum to create sustainable, energy-efficient housing.

The project was developed by Atelier Tekuto's principal, Yasuhiro Yamashita, in conjunction with the Miyashita Laboratory at the Kanazawa Institute of Technology.

Yamashita's aim was to create a house with "zero operating costs" and to explore aluminum's possibilities as both structure and radiator. His challenges were to use natural energy as much as possible and reduce the cost and environmental impact of heating and cooling with aluminum and geothermal energy.

Aluminum is a fairly new material for Japanese construction, with regulations altered only in 2002 to permit its use in residential buildings. Because Japan's *tatekae* (scrap-and-build) patterns of construction are very wasteful, Atelier Tekuto chose aluminum for its recycling possibilities. According to Yamashita, "Although the manufacture of aluminum

requires enormous amounts of electricity, the quality of the metal stays stable and it is perfect for practicing the 3R's: Reduce, Reuse, Recycle." Aluminum is also light-weight, ductile and easy to form. Very importantly, the thermal conductivity, radiation and reflectance of aluminum can help generate warmth and maintain a steady temperature.

The A-Ring House is Atelier Tekuto's first building to employ aluminum 'rings', which are, in fact, square aluminum frames joined together to form floors, walls and ceilings for almost the entire structure, with the exception of the concrete basement. In the two earlier projects, designed in 2008 and early 2009, the rings were used in

CHAPTER 4

REUSE, RENEW, RECYCLE, RENOVATE
ALTERNATIVES TO A THROWAWAY CULTURE

For generations, an old building in a city like Tokyo was viewed as something to be demolished and replaced by something newer, bigger and more profitable. A single wooden home was seen as impractical, unprofitable and even dangerous in earthquake-prone Japan.

But with a growing awareness of the waste and pollution produced by construction and a new fascination, especially among the young, with old architecture, a renovated older house is now beginning to be considered the height of both style and sustainability.

This section looks at two repurposed buildings and renovation projects that offer practical examples of how old buildings anywhere can be made contemporary, stylish and sustainable using a clever mix of the best of old and new design.

Kyoto, a city long famed for its historic built environment, has also gained a more recent reputation for shortsighted redevelopment practices and the destruction of many historic *machiya*, mostly two-story wooden merchant townhouses. But various individuals and groups have set out to save Kyoto's *machiya* from demolition, transforming them into exquisitely designed contemporary residences, such as the Shinmachi House that was repurposed by designer Fujimura Masatsugu as a luxury rental property.

Chiba-based Igawa Architects believes that traditional rural houses, part of the agricultural life cycle and made of naturally renewable materials, have much to teach the contemporary home builder. Their Old Japanese Timber House Renovation turns a ramshackle farmhouse into an elegant twenty-first century residence.

OLD JAPANESE TIMBER HOUSE RENOVATION

ARCHITECT IGAWA ARCHITECTS

LOCATION TOMISATO, IBARAKI PREFECTURE

COMPLETION 2012

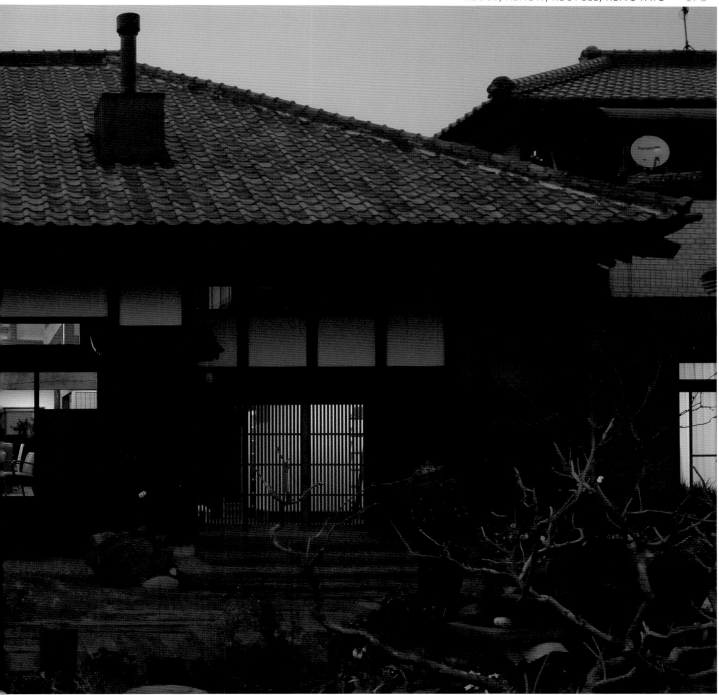

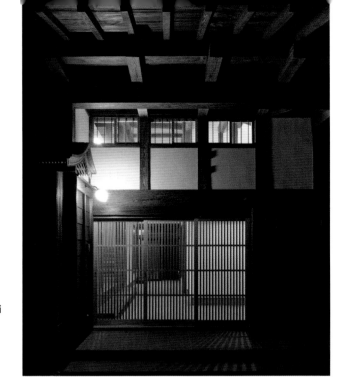

The traditional family house is arguably one of the most sustainable forms in the history of Japanese architecture. Part of the agricultural life cycle and made of naturally renewable and recyclable materials, it has much to teach the contemporary house builder. This is a tenet of the practice of architect Kazuyuki Igawa and his firm Igawa Architects, whose work features several projects to save and renovate traditional homes for the twenty-first century.

One of his most impressive renovation projects to date is this 90-year-old family home in Ibaraki prefecture. When the present owner returned with her young family to the house built by her grandfather, it was badly in need of repair. Her family considered doing what many traditional home inheritors do: demolish the house and build a new one.

There are many common complaints about old houses, says Igawa. They are a fire hazard, a quake risk, moldy, damp, drafty, cold in winter and, worst of all for some, 'old-fashioned'. In a culture where the new and modern is most valued, to be old does not add value or cache, it is simply passé. "Because of all this, many people see no value in these houses," says Igawa. "They think they cannot be renovated, that it is more economical to tear down and build a new house. But that is simply not true." Igawa points out that economically a full renovation is rarely more expensive than a new house and often less expensive. And with a thoughtful renovation, an old home can be made as safe, comfortable and up to date as any newly built house with much less waste of materials and of history. Japan, like all developed countries, produces enormous amounts of construction waste each year, exacerbated by a strong Japanese preference to scrap and rebuild. Much of Japanese house stock is built after 1980 and most houses are demolished after only about 30 years of use. This self-destructive cycle is something Igawa is trying to reverse.

He was successful in convincing this particular family that there was, in fact, multifaceted value in renovating their old Japanese timber house. It was a happy decision for the family. Not only did they end up with a beautiful, functional and contemporary home, the renovation project was awarded the prestigious Japanese Good Design Award and was listed as one of the 100 Designs of the Year in 2012.

The design was all about creating a modern living space for a young, growing family within the framework of the

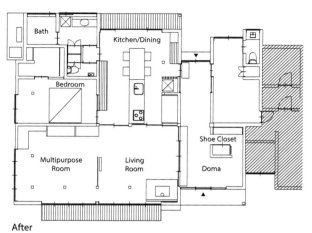

After

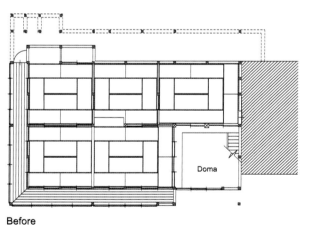

Before

Previous spread The house retains its traditional silhouette defined by an elegant tiled hipped roof.

Opposite The welcoming slatted door entryway is sheltered under deep eaves.

Bath

Kitchen/Dining

Bedroom

Multipurpose Room

Living Room

Shoe Closet

Doma

Doma

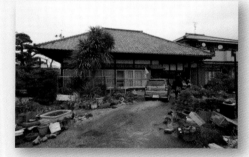

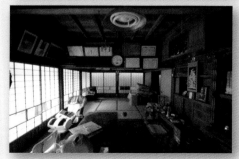

Far left The house layout before and after renovation. Traditional spaces have been updated for modern family use.

Above The former packed earthen floor (*doma*) is transformed into an elegant entry hall and shoe closet.

Above left View of the house before renovation.

Left The interior prior ro renovation was dark and cluttered from years of more traditional use.

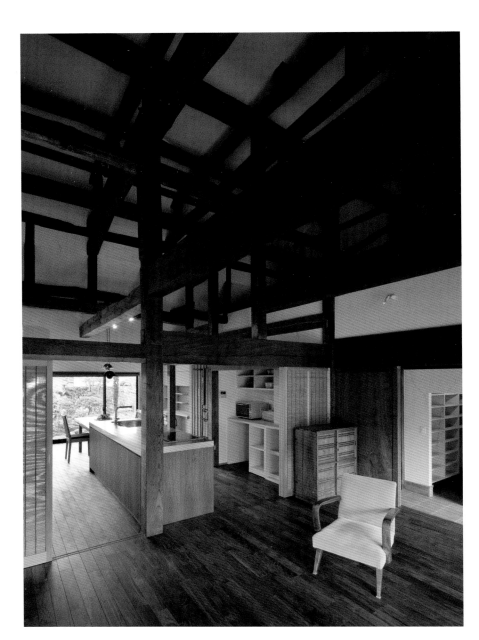

Left The updated double-height open living/ dining/kitchen area echoes the flexibility of traditional interior space by using sliding and removable screens.

traditional character of the architecture, its relationship to its surroundings and to the long history of the family. This was to be a house that respected both past and future.

Throughout, there is a deliberate mixing of old and new and traditional and modern technologies. The architect made a conscious effort to keep the history of the house intact, approaching the renovations as a dialogue between various generations of the family. Igawa's renovations take in every aspect of the structure, keeping what is useful and beautiful from the past and mixing it with contemporary technology to create new potential in old structures.

The overall profile of the house was retained, and the sturdy wooden beams crisscrossing the façades and interior provide a distinct framework for the whole design. The house was basically dismantled, maintaining the wooden 'bones' and the wide pitched roof, following similar techniques that have been used for generations in the periodic renovation of Buddhist temples and Shinto shrine buildings. Worn beams were replaced and the entire structure raised to create an up-to-date, seismically sound foundation.

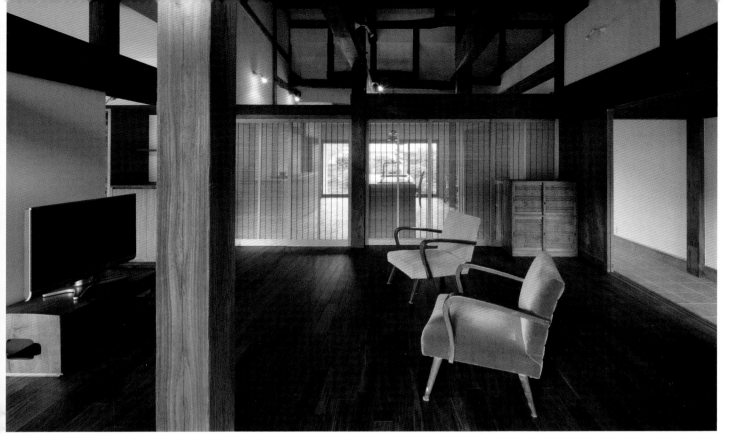

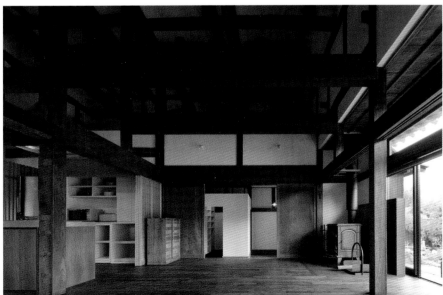

Above Translucent bamboo sliding doors can divide or open living and dining space as needed.
Left The view from the living area to the entry hallway, including a wood burning stove.

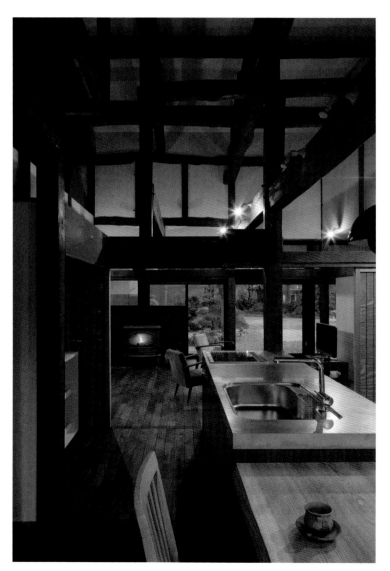

Left The view from the kitchen into the living area. **Right** Sturdy wooden beams crisscrossing the façade and interior provide a framework for the whole design.

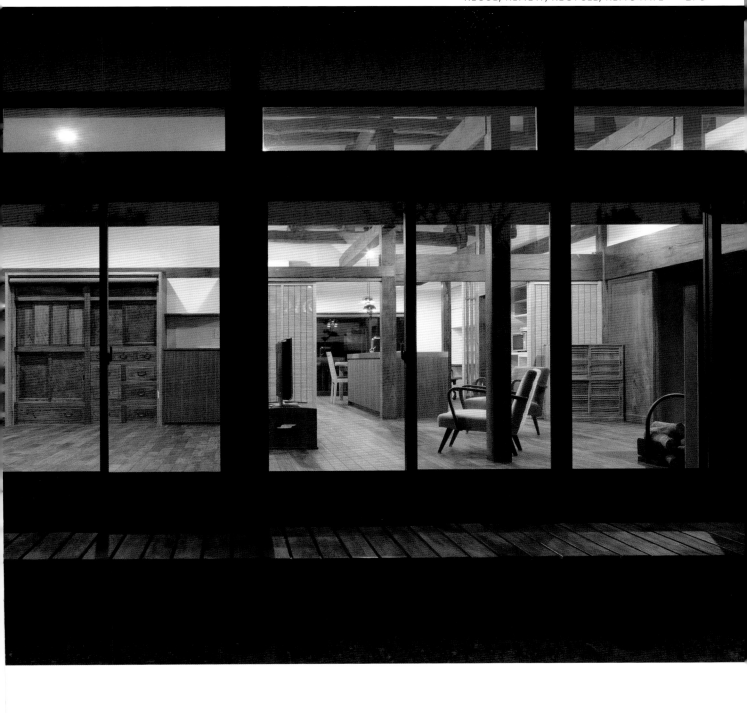

SHINMACHI HOUSE

ARCHITECT FUJIMURA MASATSUGU AND
NOGUCHI CORPORATION

LOCATION CENTRAL KYOTO

COMPLETION 1908 HOUSE, RENOVATED
2011

Previous spread The traditional multifunctional living area on the ground floor set up for dining.
Above A flagstone path leads to the entrance, discreetly tucked behind a bamboo fence and greenery.

Arriving at the gargantuan 1990s Kyoto station, first-time visitors could be excused for thinking they had gotten off the train at the wrong station. For most people, Kyoto still conjures up gracious images of temples, geishas and Zen gardens. But modern Kyoto has been on a somewhat controversial building boom for many decades, and while popular tourist temples and shrines on the edges of the city have been well preserved, the historic center of the city has been transformed.

First laid out in an auspicious grid plan in the eighth century, Kyoto was one of the few Japanese cities spared in the Second World War because of its important cultural heritage. The straight streets of its commercial center remained lined with mostly two-story wooden townhouses called *machiya* or, more specifically, *kyo-machiya*, well into the later twentieth century. Often combining a family business and residence, *machiya* were an urban artisanal/mercantile version of the traditional Japanese house and were part of the framework of daily life in urban Kyoto.

Over the past decades, however, numerous *machiya* have been destroyed and replaced by more profitable, ever higher towers. Various civic groups have worked to try to halt the destruction and stem the rise of nondescript mid-rises in Japan's most iconic city. But since the end of the war, regulations forbid the building of new wooden *machiya* and many older *machiya* owners have felt they cannot afford to update their historic homes to new seismic and fire standards. Victims of neglect, a conviction that Kyoto should 'modernize', rising land prices and often questionable urban redevelopment, *machiya* seem to come down almost daily in Kyoto. Numbers vary but one survey notes that between 1996 and 2002 13 percent of the 28,000 *machiya* in Kyoto were demolished. A 2008 survey suggests the demolition rate to be about 2 percent per year. The land is then used as a parking lot or for a new multistory development.

Various enterprising individuals and companies have, however, set out to try to save remaining *machiya* from demolition, transforming them into exquisitely designed contemporary residences. Aoi Stay Kyoto has done just this with several houses available for short-term rental throughout Kyoto. The company's motto is *mottainai*, an old Japanese concept that can be roughly translated as 'waste not, want

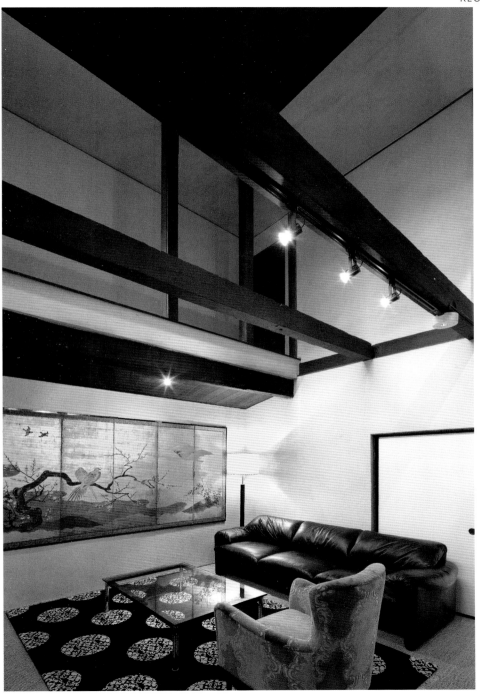

Left The modern double-height living room with original wooden beams exposed overhead.

not'. Reusing the traditional materials of Japanese architecture mixed with contemporary technologies, the company is doing its part to save Kyoto's historic urban landscape and push Kyoto's residential architecture in new directions.

The renovation of the near 100-year-old Shinmachi House was the work of Fujimura Masatsugu, a designer with CN (Creative Network) Japan, who has been involved in numerous *machiya* restorations.

Shinmachi House was once a saké brewery and later the home of a precious metal dealer. It is a classic *kyo-machiya* with a narrow façade (*machiya* were taxed based on street frontage) in front of a deep two-story house, hence the *machiya* nickname 'eel's residence'.) The house mixes old and new, east and west. Traditional *machiya* were constructed with earthen walls, thick wood pillars and tile roofs. Interiors were multifunctional but always featured sliding doors and *tatami* rooms.

Shinmachi House's entryway is indirectly accessed from the street, behind a wall of bamboo. After removing shoes, one steps up into a welcoming wooden *genkan*. This traditional entry opens into a double-height Western-style living room with original wooden beams exposed overhead. A small modern kitchen is concealed behind

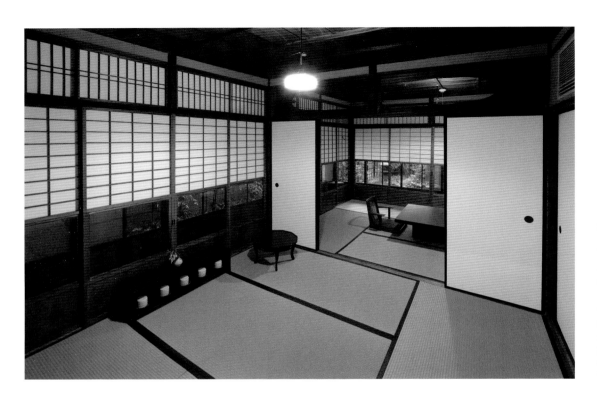

Left Two traditional *tatami* rooms enclosed by partially opaque and partially glass sliding doors open to a raised *engawa* and a small courtyard garden.

Below left Plans of the ground and upper floor of the main house and the rear *kura* building.

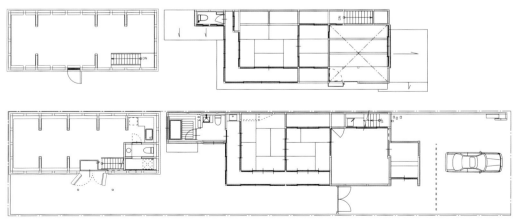

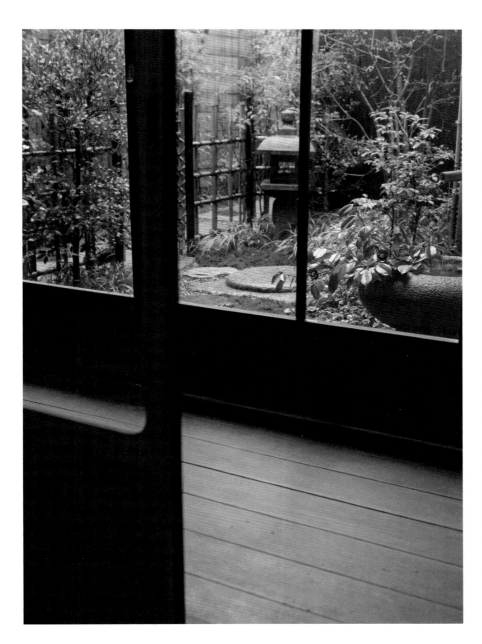

Left A view from the interior to the *engawa* and beyond to the tiny back garden space.

sliding bamboo doors. An elegant golden *byōbu* (folding screen) acts almost as a foil to the flat screen television on the neighboring wall.

Going deeper into the house, sliding doors lead to two traditional *tatami* rooms enclosed by partially opaque and partially glass sliding doors that open to a raised passageway and a little courtyard garden. While the designer has added modern in-floor heating and air-conditioning, the space is naturally cooled as it would have been in the past, with deep eaves, wide openings and a shady garden. Beyond, the bathing room has a tub of *koyamaki* (Japanese umbrella pine) and a discreet window onto greenery.

Dark wood stairs along the inner earthen wall lead up to an elegant *tatami* room, which functions as the main bedroom overlooking the courtyard. Even in summer humidity, the wood, *tatami*, earthen wall and garden give the house the clean grassy scent of an old Japanese house, not the musty smell often found in badly insulated modern homes.

The residence was not all that was restored. Behind the *machiya* stands the renovated saké *kura*, a freestanding storage

house whose thick earthen walls keep the interior naturally cool and provide an ideal environment for the art collection of Aoi's president.

The philosophy of the reconstruction was to prioritize the traditional natural materials used in *machiya* construction—wood, earth and paper—allowing the structure to age gracefully, adding patina and charm instead of decay. Over time, repairs will, of course, be needed but at far less cost than the usual scrap-and-build techniques of contemporary Japanese home construction. Even the amenities have been chosen in the spirit of *mottinai* from locally produced organic cotton towels (http://www. ikeuchitowel.com) and handmade *washi* (rice) paper by a Kyoto master, Kamisoe.

Of course, *machiya* renovations do not come cheaply and a concrete high-rise can earn more income. But factoring in the longer life cycle of the house, the retention of a human scale, the natural, recyclable materials and the preservation of Kyoto's historic urban landscape, there is value in restoring old houses for practical modern use. And there is something in being able to experience the use of space in a traditional house: the delicate partitioning of sliding doors, the feel of *tatami* underfoot, the glimpses of gardens through windows and screens.

These are revelations that the Shinmachi House is sharing with every visitor. The majority of tourists coming to Kyoto are from Japan. In 2012, of 12.2 million

Opposite The modern bathing room has a full Japanese wet room with a tub of *koyamaki* (Japanese umbrella pine) and a ribbon window onto greenery.

Below Mixing old and new, the upper floor *tatami* room functions as the main bedroom with *futon* beds set up in the evening.

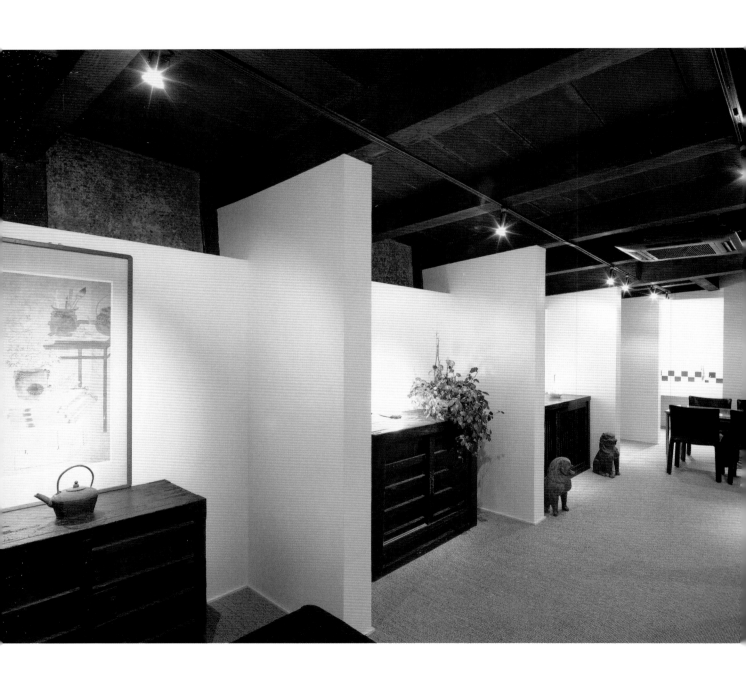

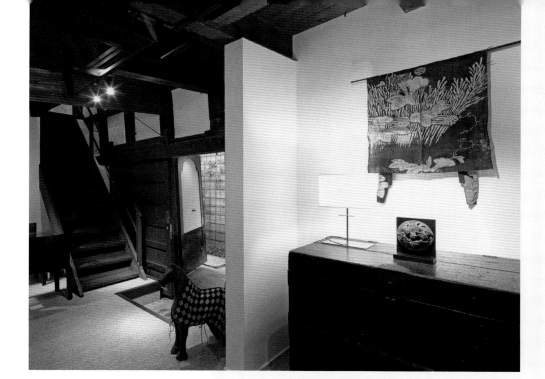

Left The upper level of the *kura* storehouse provides an ideal environment for the display of the art collection of Aoi's president.

Above The *kura*'s thick earthen walls and sturdy wooden beams and stairs reflect its former life as a saké storage house.

Above The 100-year-old property was in total disrepair and in danger of demolition before its renovation. The philosophy of the reconstruction was to prioritize traditional natural materials and use as much of the original design and structure as possible.

overnight visitors, fewer than 900,000 were foreigners. Shinmachi House gives each visitor a chance to see the naturally eco benefits of traditional architecture and materials and the possibilities of modern *machiya* living.

The city of Kyoto is beginning to respond to a growing interest in these modernized old spaces. A new small subsidy for *machiya* owners came into effect in 2014 to help preserve the buildings. However, while loans of up to about US$50,000 can be obtained to renovate old houses, up to $500,000 is available to tear down and rebuild a new home on the same plot. Still, a small step towards an appreciation of historic spaces reflects growing pressure to consider more than profit in city planning. Sustainability, livability, beauty, heritage and *mottanai* may again become commonplace on the streets of Kyoto.

REUSE, RECYCLE AND RENOVATE
ECO MATERIALS
TRADITIONAL JAPANESE ECO TECHNIQUES
NEIGHBORHOOD FRIENDLY

Right Thick dark beams overhead and *tatami* underfoot create a traditional feel to a decidedly modern space.

Left The structural beams and the thick earthen walls of the *kura* were used to articulate the space in a fresh modern way.

ARCHITECTURE OF THE PEOPLE: URBAN AND RURAL

MACHIYA

Machiya are townhouses, which were the homes and workplaces of the merchant and artisan classes in pre-modern Japan. The layout of the house reflected the layout of the town. Thus, in Kyoto, a city laid out on a grid plan, *machiya* sites are often long and thin, leading to the nickname 'eel's residence'. The narrow façade was also a tax-saving design element, given that households were taxed based on street frontage. Shops or studios were usually built at street level with residential space flowing behind and on the upper floor. *Kura*, thick-walled, whitewashed, tile-roofed storehouses, were often built next to *machiya*. Fire, heat and moisture-resistant, they are ideal for the storage of goods and merchandise.

In the later twentieth century, modern houses and apartment towers were preferred to 'old-fashioned' *machiya* and many have been destroyed to make way for new construction. But more recently, a new generation has developed an interest in traditional and sustainable architecture. A growing awareness of the impact of the loss of urban history, with its human scale and traditional charm, has meant an upsurge in the preservation and restoration or repurposing of *machiya*. Various organizations and individuals are preserving and transforming *machiya* into contemporary residences and rentals, the latter often fully booked by local and foreign tourists eager to experience life in a traditional townhouse.

Above The street frontage of a traditional *machiya*.
Below The varying façades along a street of *machiya*.

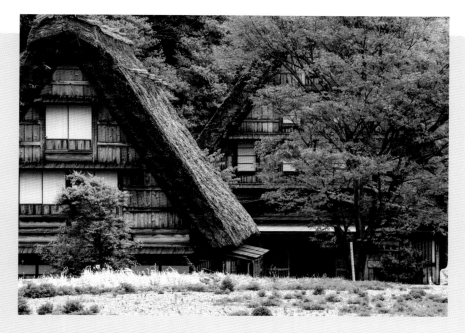

Right The thick thatched roofs of *minka* farmhouses.

MINKA

The term *minka* means 'house of the people' and covers a wide variety of pre-modern rural residential styles. These houses vary according to region, climate and era, but they are generally characterized by sturdy wood construction and distinctive pitched roofs, often covered with thick thatch. Mixing work and living space, the interiors are divided between work areas with a packed earthen floor (*doma*) and raised areas of wood or *tatami* flooring. A focal point is usually a central open hearth, or *irori*.

Many of the *minka* that survive today are now in open-air museums or in remote regions now designated as areas of architectural heritage. For example, the UNESCO world heritage sites of Shirakawa-go and Gokayama are tucked in steep mountain valleys where heavy snowfall helped define the region's *gasshō* (lit. 'praying hands')-style *minka*, with its high, steep-pitched roof. As traditional architecture regains popularity among contemporary house builders, rural *minka* are also sometimes purchased, dismantled and then reassembled and modernized in a more convenient location for the new owner.

A remarkable pioneer in *minka* preservation and reuse is Chiiori, a 300-year-old thatched roof rural farmhouse in the Iya Valley in western Tokushima. The house was saved from destruction and remodeled by author Alex Kerr, a long-time advocate for preserving the natural and built environment of historic Japan. When he began restoration work on Chiiori in the 1970s, *minka* were frequently demolished or abandoned, the result of declining rural populations and a lack of appreciation for these historic buildings. They were considered old, impractical and out of step with modern life. Kerr's aim was to demonstrate that these houses held great value on many levels: personal, cultural, communal and environmental. Today, the house is available for visits and overnight stays and is a popular destination with both foreign and Japanese tourists eager to experience life in a traditional Japanese farmhouse. With its open *irori* and bare wood floors and rafter ceilings, the house offers a rare connection to the ancient heritage of rural Japan.

The initial Chiiori *minka* restoration has evolved into the NPO, Chiiori Trust, which has also restored old houses in other areas of Japan. The Trust's aim is to revive rural areas through sustainable tourism and the rediscovery of the value of the natural environment by promoting organic agriculture and preserving old farmhouses.

Chiiori Trust and Chiiori Stay—http://chiiori.org/stay/stay.html

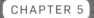

SUSTAINABLE JAPAN ABROAD
THE INTERNATIONAL IMPACT OF JAPANESE DESIGN

From the rustic simplicity of Zen to the neon vitality of *manga*, all have found fans worldwide. Traditional Japanese houses have inspired architects outside of Japan for generations, such as the early twentieth-century American architects Frank Lloyd Wright and Greene & Greene. With the growing awareness of the need for sustainability in the built environment, builders are looking to many cultures for clues on creating a more sustainable future. As Japan's traditional wood architecture was 100 percent recyclable and characterized by a variety of naturally sustainable techniques, it is inspiring a new generation of environment-minded architects.

Scotland-based architectural firm Konishi Gaffney demonstrates the natural affinities between Scottish and Japanese aesthetics in their Edinburgh Japanese house. Inspired by the earthy teahouse aesthetics of Japanese architect Terunobu Fujimori, A1 Architects in Prague, Czech Republic, have built a Bohemia house with eco materials and in a *wabi sabi* style. And in Canada, Studio Junction reinterprets the Japanese *machiya* (wooden merchant townhouse) for a row house in urban Toronto.

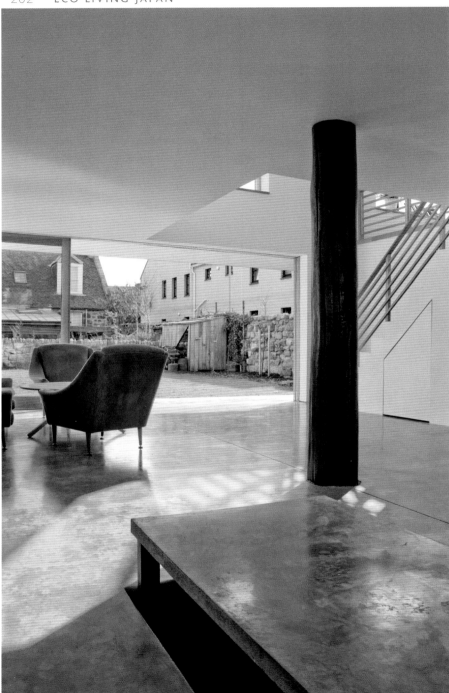

Left To the back of the living area and the charred pillar is a built-in *hori kotatsu*, a low table for eating and working with space below for legs.
Opposite above To balance the desire for privacy and for natural light, the lower street façade is closed with openings that multiply as the house rises.

technique of using charred cedar (see page 232), here adapted to Scottish oak, as water-, fire- and bug-proofing.

The garden face is far from typical, with the upper level windows flush into the wall and roof with an entire glazed corner facing south. From here, sunlight falls diagonally via a double-height space onto thermal massing concrete floors in the living room. The ground floor opens to the garden with three large sliding glass doors that receive early morning light, beginning the passive heating cycle.

The broad glazed opening also creates a porous divide/link between interior and garden. The sliding doors are set flush to the concrete floor, which continues outside creating an *engawa* (exterior passageway)-like space, which is protected from the elements by an eave-like flat roof overhang. "We were interested in the variegation of space in Japan from the core of the traditional house to the outside through a series of ambivalent spaces," explains Gaffney.

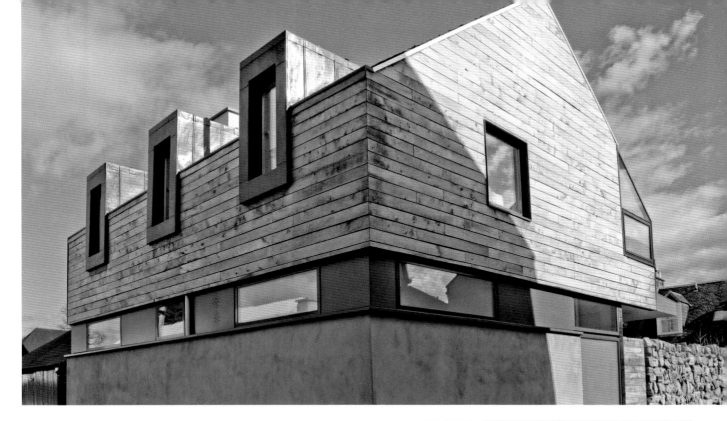

Left The wood pillar cast into the polished concrete floor recalls the *daikokubashira*, the main structural support and symbolic root of the traditional Japanese farmhouse.

Above The sliding doors are set flush into the concrete floor and create a porous divide/link between interior and garden.

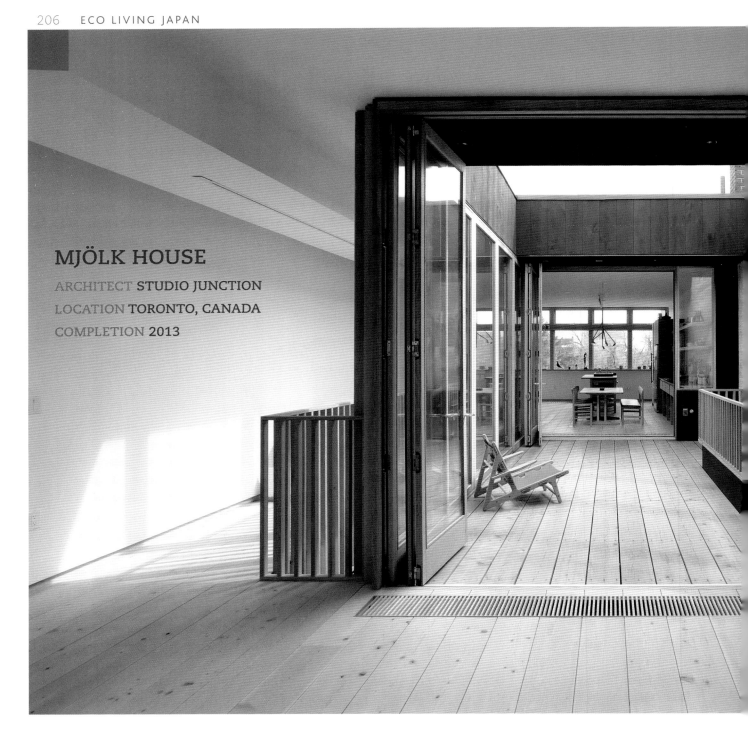

MJÖLK HOUSE

ARCHITECT **STUDIO JUNCTION**
LOCATION **TORONTO, CANADA**
COMPLETION **2013**

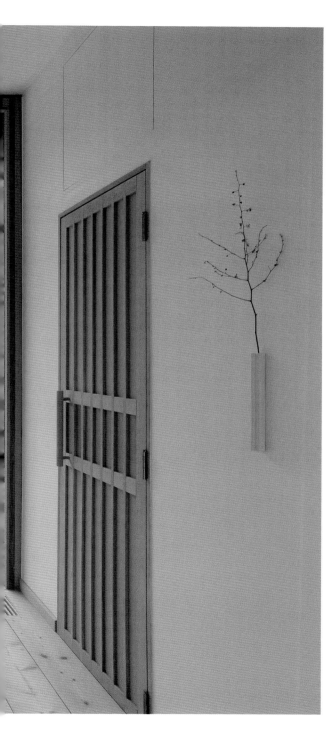

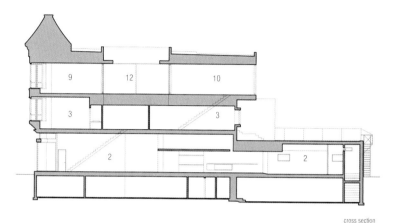

cross section

In dense, urban Toronto, Studio Junction remodeled a tired late nineteenth-century row house into a stylish family residence and workspace. Revitalizing the form and function of traditional live/work row houses common in many Canadian cities, the architects also took inspiration from similar Asian shop house traditions, such as the Japanese *machiya* (see page 194). The international outlook makes for a design that fits easily into the multicultural and mixed-use character of urban Canadian spaces.

The exterior reflects the scale and format of neighboring buildings: a long, narrow, three-floor row house with a shop on the ground floor facing the main street and an apartment above. Its original 1889 bay windows and now rare pressed metal façade were restored. Mjölk (pronounced 'mi-yelk') is the Swedish word for milk, and is the name of the ground floor shop selling Scandinavian and Japanese design products. The shop's name is meant to suggest the "pure aesthetic of the north" and, indeed, the overall design aesthetic of the family's shop and upstairs residence is a clean-cut Canadian take on Nordic–Japanese design.

The residence is spread over two long narrow floors with the bedrooms on the first floor and living and dining space above.

Responding to its layout and busy urban setting, which offered no garden space, hard to light interiors and city noise, courtyards and lightwells were incorporated for privacy, outdoor space, natural light and air.

The top floor living and dining spaces open via bi-folding glass doors onto the inner courtyard, echoing traditional Chinese skywell interior courtyards, adding to the pan-Asian concept of the design. The space is accented with natural and Japanese-inspired charred wood (see page 232) that has been given a natural oil finish.

Echoing the shop's focus on functional craftsmanship, wood is used to define spaces and add a warmth much needed in

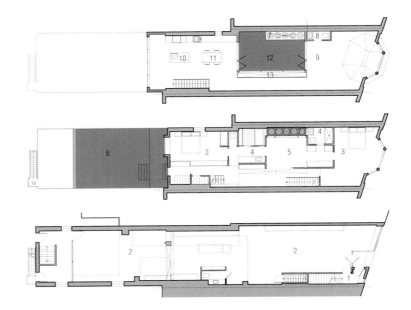

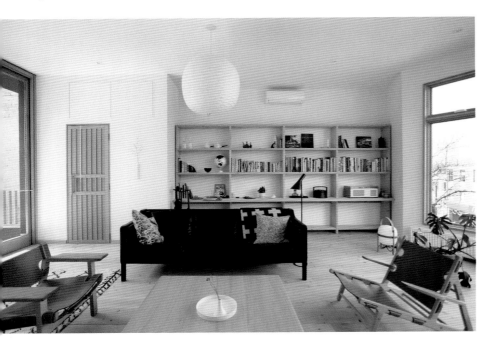

the cold and often gray Canadian winter. Complex plywood features, such as cabinets, were formed with computer modeling and CNC (computer-controlled cutting), while other elements, such as the white oak sliding doors, were created by traditional hands-on woodworking. Furniture and fitting are primarily white oak, while Douglas Fir is used for the flooring and living room shelving units. Reclaimed/recycled materials, such as wood and glass, are used throughout.

To minimize heat in summer and maximize warmth in winter, heating and cooling are organized by zones, with adjustable radiators, ductless air-conditioning, good insulation and a wood burning stove, while the courtyard and awning windows offer cross-ventilation.

Previous spread left View through the top floor inner courtyard into the dining and kitchen area.

Previous spread right Cross-sectional plan of the townhouse showing the ground-floor shop (2) and two-level apartment above.

Opposite above Plans of the three floors: ground floor shop and two-level apartment.

Opposite below The top floor living room is accented with custom-made white oak and Douglas fir fixtures.

Right Complex plywood features, such as the kitchen cabinets, were formed with computer modeling and CNC (computer-controlled) cutting.

Below The inner courtyard acts as a skywell, bringing light and fresh air (in warm weather) into the home.

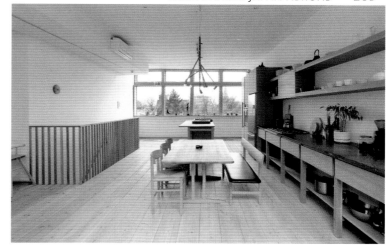

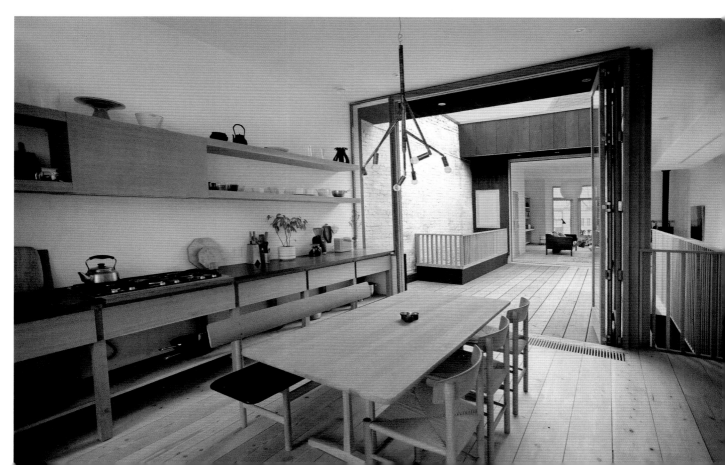

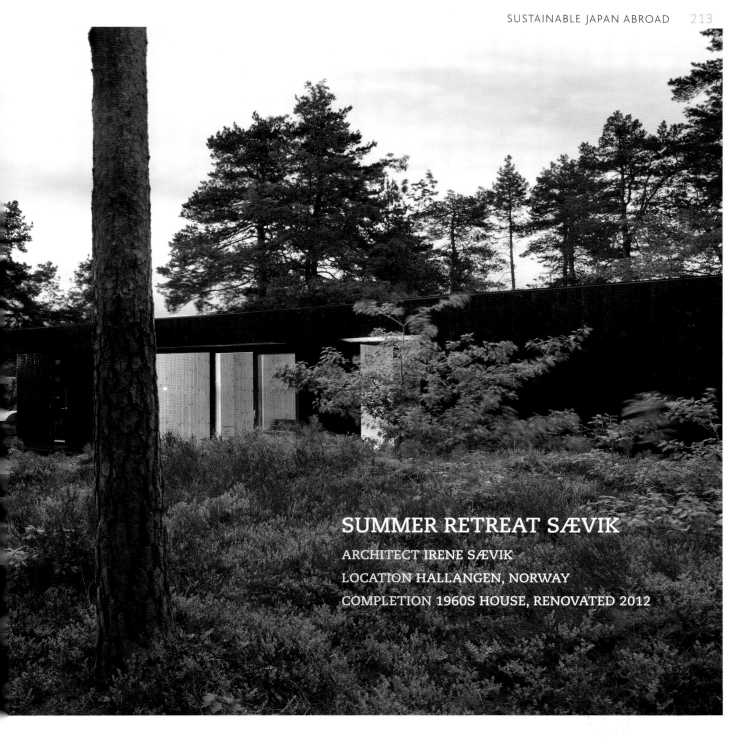

SUMMER RETREAT SÆVIK

ARCHITECT IRENE SÆVIK

LOCATION HALLANGEN, NORWAY

COMPLETION 1960S HOUSE, RENOVATED 2012

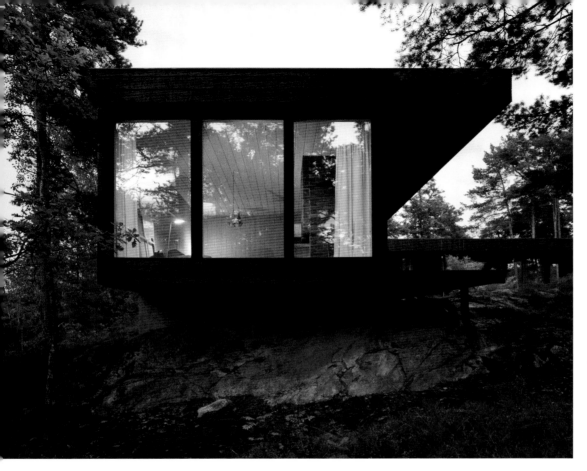

Previous spread The exterior is a textured charred wood, a technique traditional to both Japan and Scandinavia.
Left One arm of the retreat extends over a rock outcrop, balanced on slender pillars.
Below Cross-sectional drawing of house in landscape.

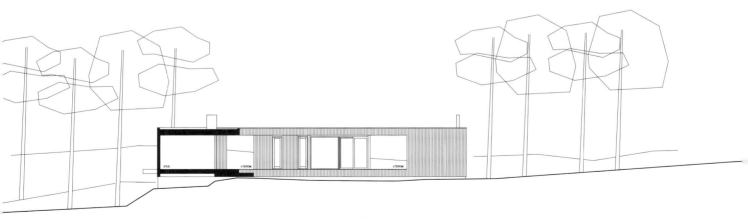

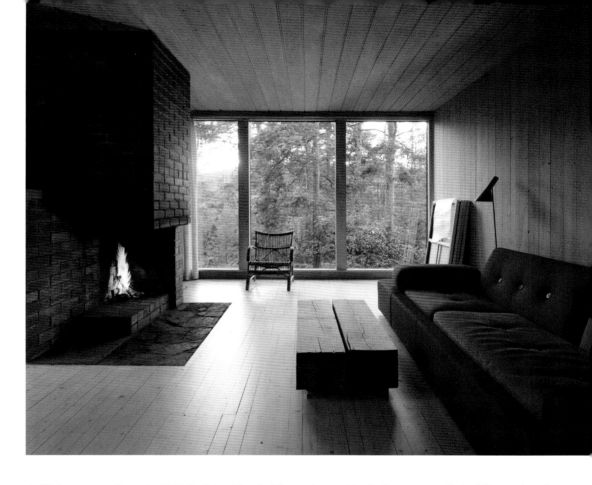

Right Japanese-style 'borrowed landscape' of the surrounding Nordic forest enter via broad glazed openings stretching from floor to ceiling.

There appears to be a natural affinity between Nordic and Japanese aesthetics. Perhaps it comes from the abundance of wood or the traditional connections to nature, or to the penchant for frugal minimalism that fits so well with modern design. All are found in Norwegian architect Irene Sævik's Zen-like summer retreat, about 40 minutes from Olso.

The house is a restructuring and expansion of a smaller-scale cottage built by Modernist Norwegian painter Irma Sahlo Jæger in 1963. Explained Sævik: "The goal was to pick up on the original building's asceticism as well as its sober Nordic Modernist ethos, influenced by Japanese architecture, and upgrade it to a contemporary contemplative hideout."

Sævik, drawing on the concept of the Japanese *engawa*, surrounded the house with a slender gallery, thus allowing free circulation between interior and exterior and adjacent rooms. Japanese-style 'borrowed landscape' of the surrounding Nordic forest enters the building via broad glazed openings stretching from floor to ceiling. One arm of the retreat extends over a rock outcrop, balanced on slender pillars, further linking house and landscape.

The exterior is a textured charred wood (see page 232), a technique traditional to both Japan and Scandinavia, while the interior is dominated by pale natural wood, a contrast Sævik used to create an "ambiguous movement between opening up and sheltering, light and shadow…".

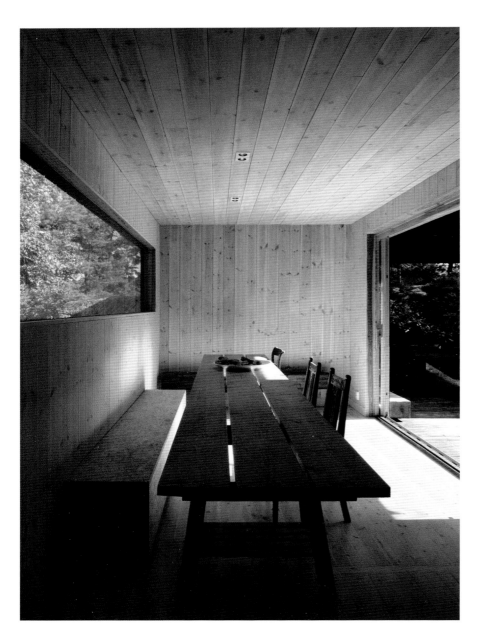

The design is minimalist, drawing on the original 1960s aesthetic and blending it into a contemporary sensibility. However, the simplicity is the result of serious reflection. Both architect and artist, Sævik considered every detail and even designed the pencil holder placed on the vintage desk that is one of several pieces salvaged from the original summer house. She also designed a wooden Japanese-style tub, which sits next to a Norwegian sauna.

Sævik explains her affinity with Japanese design as a natural extension of her own upbringing, close to nature and accustomed to a cold four-season climate: "The rough landscape and harsh climate have infused me with a sense of modesty, a thorough respect and deep fascination for nature, and a keen interest in old traditional Nordic buildings.... The traditional use of charred wood, precise volumes and galleries, proportions and use of natural light, dealing with detailing and handicraft, and the

Left The interior, in contrast to the dark exterior, is dominated by pale natural wood, facilitating a play of light and shadow.

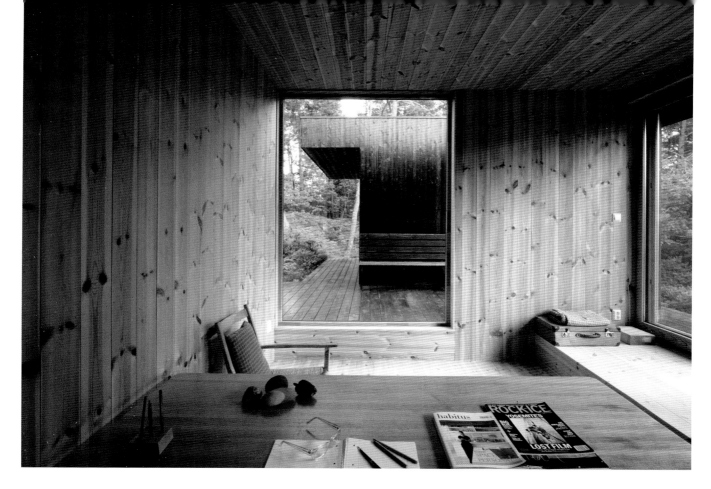

Above The design is minimalist but deeply considered. The architect/artist/owner designed every detail, down to the pencil holder on the 1960s vintage desk.

relations and topographies between the different buildings are crucial, and something that I somehow find intimately connected to Japanese architecture."

Sævik was drawn to the extreme precision and ascetic use of materials of Japanese architects like Tadao Ando, and in visiting Japan was deeply impressed by Japanese architecture's intimate connection between contemporary and traditional architecture and to nature. "I also saw the connection to a certain Nordic Modernism,

even traditional Norwegian architecture," said Sævik. "I was especially captivated by the elegant and effortless mobility around, on and in between the galleries.

"In Salo's summer house, I saw the possibility to work with all of the above, both regarding the site and the building, and in a sustainable way. Only a smaller part of the original cabin was pulled down to give way to my vision, and all of the dismantled material was later used for woodshed and furniture. The use of simple,

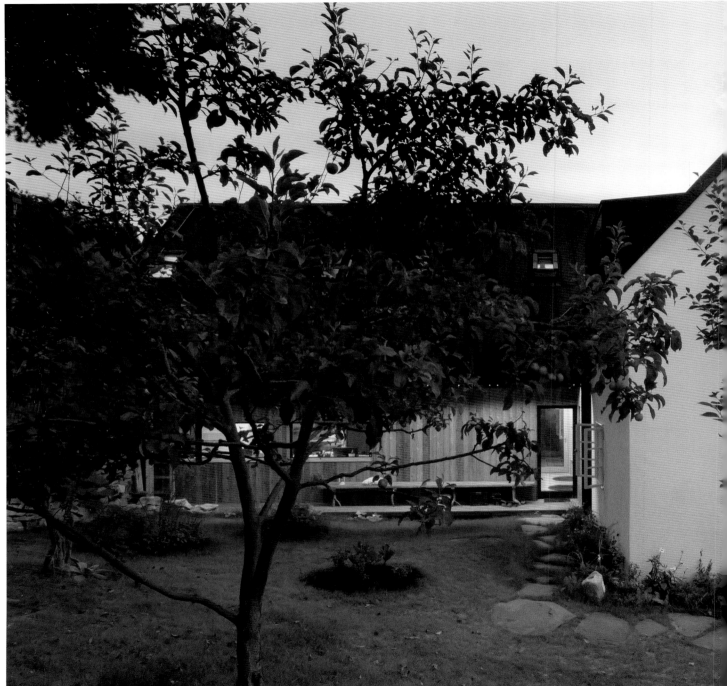

A1 HOUSE

ARCHITECT **A1 ARCHITECTS—LENKA KŘEMENOVÁ AND DAVID MAŠTÁLKA**
LOCATION **PRAGUE, CZECH REPUBLIC**
COMPLETION **2014**

The A1 House is found in a leafy residential area in Prague, the historic heart of Bohemia and contemporary capital of the Czech Republic. It is the home and studio of two young Czech architects, Lenka Křemenová and David Maštálka of A1 Architects, who share a deep interest in Japanese architecture, particularly the teahouse. Subtly standing out from its neighbors with its expressive simplicity and distinctive materials, the A1 House represents a unique junction between Czech and Japanese aesthetics.

The architects originally took inspiration from the work of celebrated architect/historian Terunobu Fujimori (see Charred Wood page 232). After seeing his work at the 2006 Venice Biennale, the pair traveled to Japan, meeting Fujimori and gaining a new perspective on architecture.

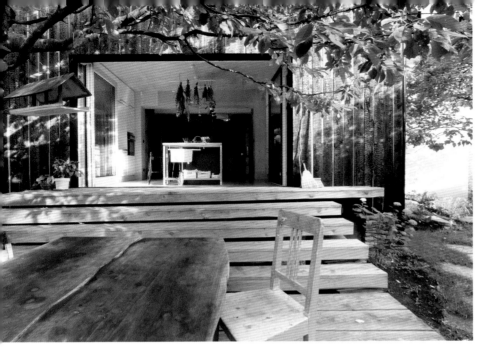

Previous spread The A1 House combines a 200-year-old house and a new wooden extension, which runs through the middle of the old structure, creating a cruciform layout.
Left View into the kitchen from the terrace.
Below left The plan: 1. Courtyard, 2. Entrance, 3. Studio, 4. Hall, 5. Kitchen, 6. Dining room, 7. Living room, 11. Meeting room, 13. Terrace.
Below Rustic gardens surround the house.
Opposite The plank wood corridor between the studio and meeting room.

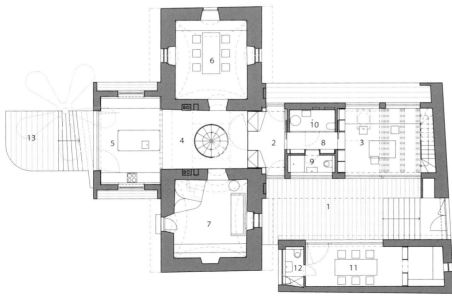

Fujimori, best known for his poetic teahouses, uses natural materials—wood, earth, stone and grass—to create whimsical and earthy forms that draw on Japan's traditional architecture. He builds in a way that is ecological, historically aware and sustainable, all values that speak deeply to a new generation of international architects like A1.

Křemenová and Maštálka's first project on returning to Prague was a teahouse, in which they looked to "connect and interpret the architecture of West and East", not by copying a Japanese teahouse but by reinterpreting its inherent qualities—rustic simplicity and frugal elegance—in a Czech building. The result was a sort of modern Bohemian *wabi sabi*, a style that continued to evolve in the design of the A1 House.

The four-year project began with a 200-year-old house, a long, narrow laborer's cottage of stone and plaster in the former village of Hloubětín, now a residential area of Prague. To open up its shadowy, thick-walled interior, the architects ran a long new wooden extension through the middle of the old structure, creating a cruciform layout. Much effort was spent to harmoniously and legibly integrate the new and old structures. Both parts share a similar gabled roof profile but contrast in their materials. While the old house has a traditional white plaster finish, the new is a timber construction. Its cladding is comprised of natural wood and a silvery charred wood made using a traditional Japanese technique (see

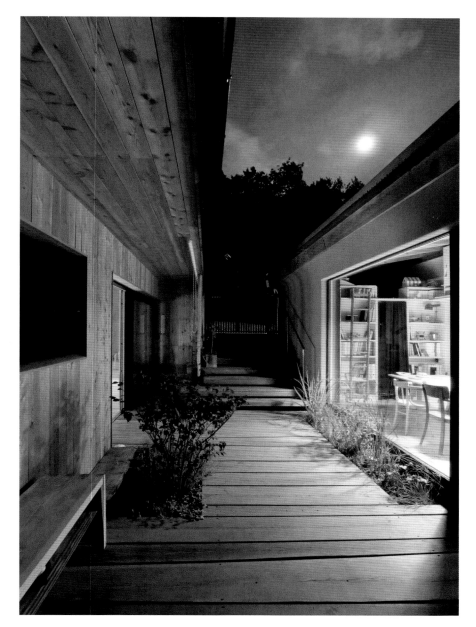

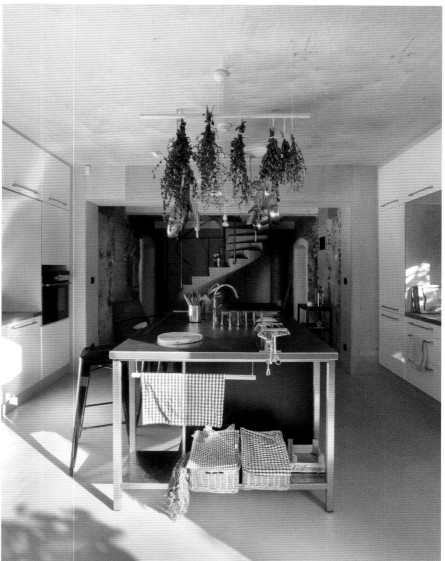

page 232) that the architects learned from Fujimori when he, in turn, visited the Czech Republic. The dark wooden cladding offers a pleasing contrast to the pale molded surfaces of the old house. Wild flowers and mature trees are sprinkled throughout the surrounding garden, complementing the natural materials of the building and enhancing the bucolic feel of the property.

The layout mediates between the more public space of the studio and the more private space of the home. The entrance gate opens into a public courtyard with wooden planks underfoot dotted with small patches of mixed grass and plants. On either side is a studio and a meeting space looking back at one another through broad glazed openings. The studio space is

Opposite In the hall, a freestanding staircase of textured gray concrete spirals upward, recalling the virtuoso staircases of historic Czech architecture.
Above left A moon-shaped window looking into the studio.
Above The kitchen space echoes the earthy, organic colors and textures used throughout the house.

part of the new wooden house extension and offers a textural and color contrast to the taupe molded plaster exterior of the meeting room, an old detached storage space converted for studio use. Adding to the multitude of surfaces, the meeting space has a slanted green roof of wild plants, which creates verdant views from the private upper story.

The entrance to the home is at the far end of the rectangular courtyard. Inside, both new and old parts of the house are finished in a *wabi sabi* manner with earthy, elegant surfaces and transitions. One enters into the heart of the house, the dramatic intersection of the old and new buildings. Here, a freestanding staircase of textured gray concrete spirals upward, leading to the exposed-beam upper level and recalling the virtuoso staircases characteristic of historic Czech architecture. The staircase's molded form echoes much of the expert architectural detailing throughout the house, which leans to organic shapes, colors and textures,

Above The terrace sits beside a rustic teahouse designed by A1 Architects.
Opposite left The elegantly molded walls of a narrow passageway between the living room and meeting room.
Opposite right The smooth white surface of the original house creates a pleasing contrast with the textured wood of the new addition.

echoing Fujimori's earthy handmade aesthetics as well as that of the old house with its exposed stone and expressive moldings.

To either side of the hall are the vaulted dining and living rooms of the old house, while the kitchen extends into the new wing, opening onto a private terrace and garden. The lush garden, with a dotted flagstone path leading to a tiny teahouse, becomes part of the interior aesthetic, thanks to broad glazed openings.

Good insulation helps to keep the entire structure energy-efficient. The old house has thick stone walls topped by mineral insulation, while the new part has thick insulation of environmentally friendly materials, such as recycled wood. The

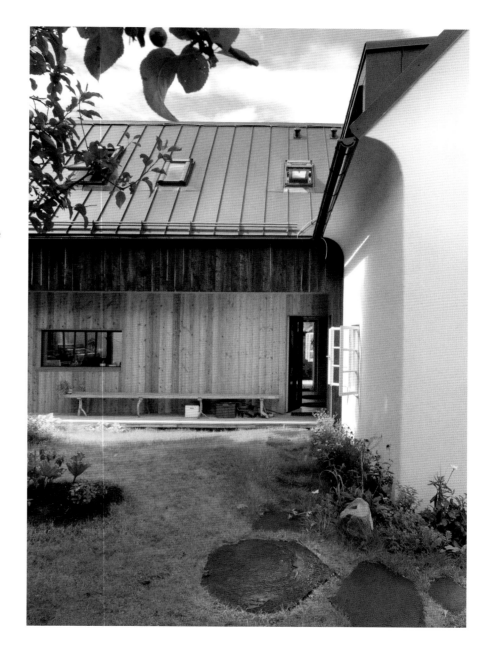

Left Varying window profiles, each with a sculptural quality accented by the wildflower greenery.
Below The dining room's thick walls are typical of the original house and provide natural insulation.

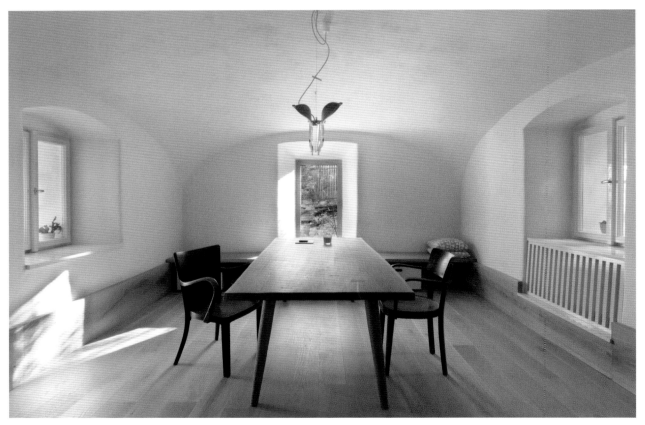

natural thermal qualities of the concrete staircase absorb and radiate the heat produced by a traditional Central European wood burning ceramic stove, adding to the house's overall energy efficiency. The green roof of the meeting room has 10–15 cm of soil as natural insulation, keeping the room warmer in winter and naturally cool in summer. Combined with good cross-ventilation, the house offers comfortable year-round temperatures with only a minimal use of active heating in the winter.

The design aim was a "harmony of contrasts", connecting house and neighbor-hood, home and office, historic and modern, local and international. Explained Křemenová: "We designed from the inside out," considering how people will live and grow in the space. It was to be a design that would fit naturally into the village-like urbanism of the neighborhood and into the lives of its residents.

Far from a simple teahouse, the A1 House nevertheless incorporates the Japa-nese teahouse spirit of simple elegance, craftsmanship, ecology and natural materiality in a way that feels completely at home in the Czech Republic.

ECO MATERIALS
JAPANESE TRADITIONAL TECHNIQUES
NEIGHBORHOOD FRIENDLY

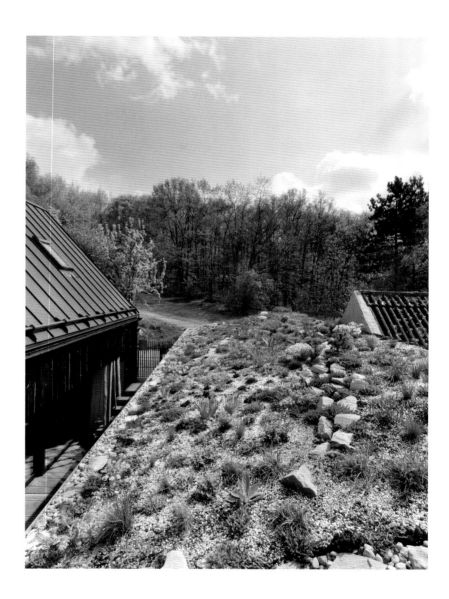

Above The green roof of the meeting space creates natural insulation, keeping the room warmer in winter and cooler in summer.

CHARRED WOOD CLADDING
ANCIENT AND NEW

Beautiful, functional and sustainable, charred wood is a pre-modern Japanese technique to seal wood against rain, insects and rot and to make it fire-resistant. Called *shou-sugi-ban* (lit. 'burning cypress board') or *yakisugi* (lit. 'burnt cypress') in Japanese, this ancient technique is enjoying a new lease on life in contemporary international design. The American magazine *Dwell* recently called it one of the most popular emerging trends in home building and wood-working, with charred wood showing up on houses from Prague to Portland.

The charm of charred wood lies not only in its functional properties but also its dynamic beauty. Its silvery textured surfaces create a magnetic visual effect of varying light and color.

The method re-emerged in contemporary design in the highly original works of architect and historian Terunobu Fujimori, who experimented with the technique in various architectural projects, such as the whimsical Charred Wood House (see photo page 235).

Fujimori's traditional method of charring the wood is to bind three boards together in a triangular shape, set the interior alight and coax the fire up the boards in a chimney-like effect. (An alternative modern method is to often simply use a torch.) After a few minutes of charring (seven, according to Fujimori's method), the boards are separated and the fire extinguished with water. The boards are brushed to remove soot, revealing a silvery layer of carbon that is resistant to mildew, insects, water and fire. The surfaces are then washed and dried and can be left without a finish or brushed with oil to bring out the varied tones in the wood. The final consistency can be anywhere from an opaque polished surface to the rich texture of tree bark.

Although time consuming, the process is a natural method of finishing wood. Stain and paint can fade but charred wood can last for decades, by some estimates up to 80 years.

Originally made using *sugi* (cryptomeria, a type of Japanese cypress), designers and architects are now using other types of wood, such as red cedar, Douglas fir, pine, cypress and oak. Each creates a different effect. Soft woods like *sugi* have prominent growth rings that create a highly textured surface, while charred hardwood has a more even surface. Often used as exterior cladding, it can also be used for floors, walls, fencing and decks with the carbonized wood's dark smoky surfaces adding contrast and texture to any design.

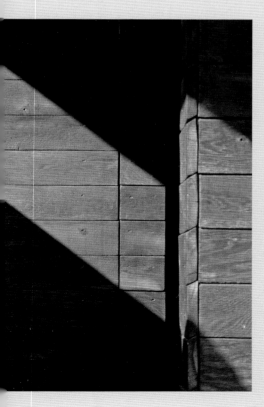

Left Charred wood surfaces, both rustic and refined.
Right A1 Architects in Prague practice Japanese traditional wood-charring techniques.

THE WABI SABI AESTHETICS OF THE TEAHOUSE

WABI: APPRECIATION OF THE BEAUTY OF THE AUSTERE, THE HUMBLE, THE SIMPLE
SABI: TAKING PLEASURE IN AGE AND IMPERFECTION
WABI SABI: TRANQUIL, AUSTERE BEAUTY, SERENE IMPERFECTION

The tea ceremony took the form it has today under Sen no Rikyū (1522–92), tea master to the great samurai leaders of the era. His design for the Taian teahouse, a small idyllic space for the performance of the tea ceremony among two or three people, is considered a prototype of teahouse aesthetics. Made with exacting craftsmanship of the very best of simple materials (wood, waddle-and-daub, thatch and paper), it is the embodiment of *wabi sabi*, a kind of rustic elegance. In a garden setting, it occupies but a small footprint, yet creates an interior space of immense meaning.

Architect and historian Terunobu Fujimori is an eloquent modern interpreter of the traditions of the teahouse. He has written: "As a locus for the tea ceremony, [the teahouse] provides an atmosphere that is at once tranquil, yet at the same time maintains a spiritual and psychological tension." This contrast of qualities, which creates a vibrant simplicity, is something Fujimori compares to the austere Romanesque churches of Europe, a Western example of beauty and meaning found in expressive minimalism.

Broadly, the teahouse aesthetic incorporates a reverence for nature, an appreciation of the innate beauty of the simple, a deep awareness of aesthetic detail and a conscious design of the spaces for camaraderie and ritual.

In modern architecture, this aesthetic often translates into qualities we now consider eco: delight in natural materials, which are also recyclable and/or biodegradable; minimalism and simplicity in design; wasting nothing; thoughtfulness to context,

to how outside and inside as well as house and neighborhood interact; close attention to detail and craftsmanship; creating healthy, hospitable spaces that are built to last and to please.

Above The *wabi sabi* interior of A1 Architect's Black Teahouse in Česká Lípa, Czech Republic.
Opposite View of the charred wood exterior of the Black Teahouse.

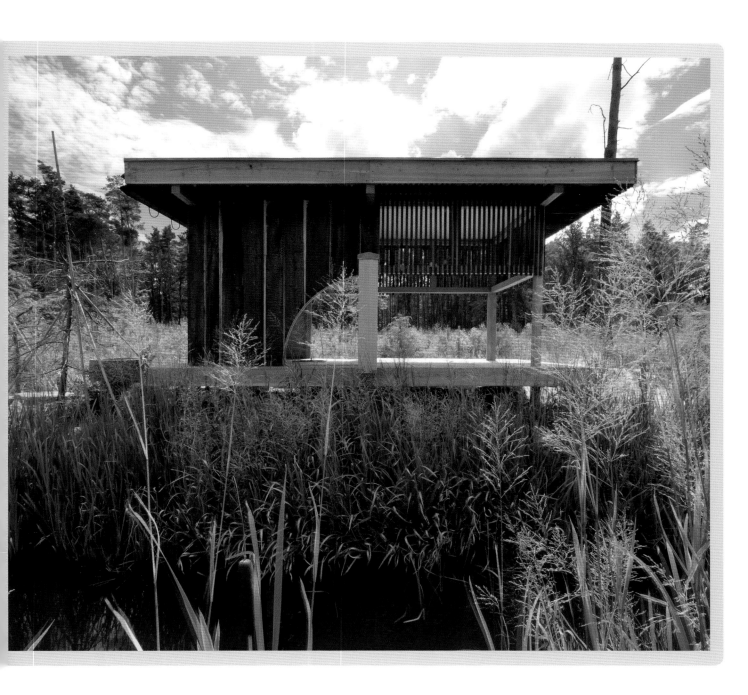

ARCHITECTS AND DESIGNERS

A1 Architects (page 222)
a1architects.cz
Hostavická 44/37
Praha 14, 19800
Czech Republic

acaa (page 24)
ac-aa.com
4-15-40-403 Nakakaigan
Chigasaki-shi
Kanagawa 253-005
Japan

architect café (page 34)
mikio tai architect associates
architect-cafe.com
501 Matsuhiro Building
3-14-8 Ginza Chuo-ku
Tokyo 104-0061
Japan

Atelier Tekuto (page 161)
tekuto.com
Jinguemai Forest Building B1F
Jinguemae 4-1-20, Shibuya
Tokyo 150-0001
Japan

BAKOKO Architects (page 151)
bakoko.jp
85-4-402 Nemoto
Matsudo
Chiba 271-0077
Japan

Edward Suzuki Associates
(page 94)
edward.net
Keyaki House 101
19-10-3 Nishi-Azabu
Minato-ku
Tokyo 106-0031
Japan

Fujimura Masatsugu (page 182)
en.kyoto-stay.jp/list/shinmachi.
html
Aoi Corporation
Tenno-cho 145-1, 4F
Kiyamachi-dori Bukkoji-agaru
Shimogyo-ku
Kyoto 600-8013
Japan

Igawa Architects (page 172)
igawa-arch.com
Kowata 613
Inashiki
Ibaraki prefecture 300-0638
Japan

Irene Sævik architect (page 212)
MNAL savik.no
Skovveien 39A
0258 Oslo
Norway

Kengo Kuma and Associates
(page 107)
kkaa.co.jp
2-24-8 BY-CUBE 2F
Minami-Aoyama, Minato-ku
Tokyo 107-0062
Japan

Key Architects (pages 107, 142)
key-architects.com
2-2-2 Ohmachi
Kamakura
Kanagawa 248-0007
Japan

Konishi Gaffney (page 199)
konishigaffney.com
132 Constitution Street
Edinburgh EH6 6AJ
Scotland

Lambiasi + Hayashi Architects
(page 127)
lh-arch.com
2-17-12-101 Aobadai
Meguro-ku
Tokyo 153-0042
Japan

rhythmdesign (page 54)
rhythmdesign.org
7-26-10-3 Okusunoki
Fukuoka Itiminami
Fukuoka 815-0082
Japan

Studio Junction (page 206)
studiojunction.ca
2087 Davenport Road
Toronto
Ontario M6N 1C9
Canada

**Takashi Okuno Architectural
Design Office** (page 84)
okunotakashi.sakura.ne.jp
2-18-1 Misake #4, 3F
Miasakemachi
Matsuyama
Ehime prefecture 790-0814
Japan

Uemachi Laboratory (page 42)
www.uemachi.org
Terahata 2-9-10
Kawanishi
Hyogo 666-0034
Japan

**Yasushi Horibe Architect &
Associates** (page 64)
1.ocn.ne.jp/~horibe-a/index.html
3F, 10-5 Fukuromachi,
Shinjuku-ku
Tokyo 162-0828
Japan

RESOURCE GUIDE

Sustainable Architecture

CASBEE, Comprehensive Assessment System for Built Environment Efficiency
ibec.or.jp/CASBEE/english/overviewE.htm
CASBEE is the principal system in Japan for assessing and rating the environmental performance of buildings and built environment.

JAPANESE SUSTAINABLE BUILDING DATABASE
ibec.or.jp/jsbd/
Part of a growing international database of sustainable design organized by nation, including the USA, China, Australia, etc.

LEED, Leadership in Energy & Environmental Design
usgbc.org/LEED/
The main American green building certification program.

JIA The Japan Institute of Architects
jia.or.jp/english/

AIA JAPAN
aiajapan.org
American Institute of Architects in Japan

GOOD DESIGN AWARD
g-mark.org/?locale=en
Annual awards for best designs in Japan in various categories from the latest in eco technology to house design.

PASSIVE HOUSE JAPAN
passivehouse-japan.jimdo.com (Japanese only)
The Japanese branch of PassivHaus from Germany (passiv.de/en/)

JA+U: JAPAN ARCHITECTURE + URBANISM
japlusu.com
Website of several important Japanese magazines. including *A+U* (architecture + urbanism), *JA* (*The Japan Architect*), *Shinkenchiku* (*New Architecture*) and *Jutaku Tokushu* (*Special Housing*). While the magazines are mostly in Japanese, though more and more English summaries are included, the website has a growing English component with articles and videos on Japanese architecture.

KATEIGAHO MAGAZINE— INTERNATIONAL EDITION
int.kateigaho.com
Glossy magazine published quarterly on Japanese art and culture in English. Sections focus on design and architecture.

ARCHDAILY.COM
archdaily.com
The go-to site for the latest in architectural news from around the world, featuring many articles on Japan.

Interior Design

BARTOK DESIGN JAPAN
bartokdesign.com
Italian–Japanese run company in Kobe producing bespoke *hinoki* bathtubs and all accessories for a Japanese bath. Ships internationally.

MARUNI
maruni.com/en/
Eco-friendly wood furniture maker mixing traditional craftsmanship, modern technology and fine materials to make some of the most fashionable furniture in Japan. Based in Hiroshima but sells internationally.

J-PERIOD
j-period.com/en/
Online shop of fashionable Japanese stores featuring Japanese artisan goods. Traditional craftsmanship is updated for modern living creating everyday goods, from saké cups to *hibachi*, that embody the Japanese concept of *wa* (harmony).

RAKUTEN GLOBAL
global.rakuten.com/en/
Online global retailer where you can find everything for the 'green' Japanese home, from bamboo screens (*sudare*) to *tatami* mats.

Further Reading

Mira Locher, *Traditional Japanese Architecture: An Exploration of Elements and Forms* (Tuttle Publishing, 2010)

Geeta Mehta and Deanna MacDonald, *New Japan Architecture: Recent Works by the World's Leading Architects* (Tuttle Publishing, 2011)

Geeta Mehta and Kimie Tadata, *Japan Style: Architecture Interiors Design* (Tuttle Publishing, 2005)

Published by Tuttle Publishing, an imprint of Periplus Editions (HK) Ltd

www.tuttlepublishing.com

Copyright © 2015 Periplus Editions (HK) Ltd

ISBN: 978-4-8053-1283-4

Distributed by

North America, Latin America & Europe
Tuttle Publishing
364 Innovation Drive
North Clarendon, VT 05759-9436 U.S.A.
Tel: 1 (802) 773-8930
Fax: 1 (802) 773-6993
info@tuttlepublishing.com
www.tuttlepublishing.com

Japan
Tuttle Publishing
Yaekari Building, 3rd Floor
5-4-12 Osaki
Shinagawa-ku
Tokyo 141-0032
Tel: (81) 3 5437-0171
Fax: (81) 3 5437-0755
sales@tuttle.co.jp
www.tuttle.co.jp

Asia Pacific
Berkeley Books Pte. Ltd.
61 Tai Seng Avenue, #02-12
Singapore 534167
Tel: (65) 6280-1330
Fax: (65) 6280-6290
inquiries@periplus.com.sg
www.periplus.com

18 17 16 15 10 9 8 7 6 5 4 3 2 1
Printed in Malaysia 1511TW

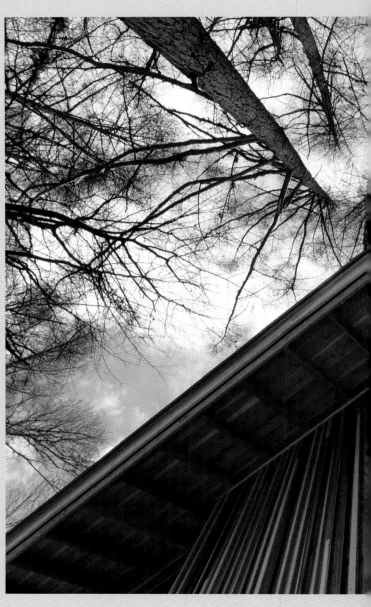

Nature and design in harmony in Yasushi Horibie's House in Tateshina.

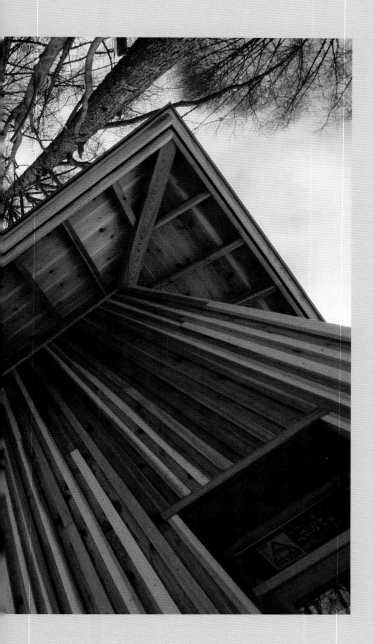

ABOUT TUTTLE

"BOOKS TO SPAN THE EAST AND WEST"

Our core mission at Tuttle Publishing is to create books which bring people together one page at a time. Tuttle was founded in 1832 in the small New England town of Rutland, Vermont (USA). Our fundamental values remain as strong today as they were then—to publish best-in-class books informing the English-speaking world about the countries and peoples of Asia. The world has become a smaller place today and Asia's economic, cultural and political influence has expanded, yet the need for meaningful dialogue and information about this diverse region has never been greater. Since 1948, Tuttle has been a leader in publishing books on the cultures, arts, cuisines, languages and literatures of Asia. Our authors and photographers have won numerous awards and Tuttle has published thousands of books on subjects ranging from martial arts to paper crafts. We welcome you to explore the wealth of information available on Asia at **www.tuttlepublishing.com**

PHOTO CREDITS

I would like to thank all the architects, designers and photographers who have so graciously provided photos and drawings for this book. The following is a list of all contributors. My sincere thanks to all for their efforts and expertise.

House in Kita-Kamakura (pages 4, 24–33): all images courtesy of acaa. **House in Komae** (pages 5, 34–41): courtesy of architect café, photographer Satoshi Asaka. **House in Nara** (pages 16, 23, 42–53): courtesy of Uemachi Laboratory, photographer Kazushi Hirano. **House in Raizan Forest** (pages 4, 6, 54–63): courtesy of Kenchiro Ide and rhythmdesign, photographer Koichi Torimura. **House in Tateshina** (pages 1, 8, 15, 64–77, 238): courtesy of Yasushi Horibe. **House in Nagahama** (pages 2–3, 84–93): courtesy of Takashi Okuno Architectural Design Office, photographer Isao Aihara. **House of Maple Leaves** (pages 4–5, 94–105): courtesy of Edward Suzuki, photographer Yasuhiro Nukamura. **Kotoboshikan** (107–15): courtesy of Key Architects. **Même Meadows** (pages 4, 21, 83, 116–25): courtesy of Kengo Kuma and Associates. **Mini Step House** (pages 126–35): courtesy of Lambiasi + Hayashi Architects. **Passsive House Karuizawa** (pages 142–8): courtesy of Key Architects, photographer Hiroshi Ueda. **Diagram** (page 149): courtesy of Passive House Institute. **Onjuku Beach House** (pages 150–9): courtesy of BAKOKO Architects. **A-Ring House** (pages 5, 141, 160–7): courtesy of Atelier Tekuto. **Old Japanese Timber House Renovation** (pages 172–81): courtesy of Igawa Architects. **Shinmachi House** (pages 4, 171, 182–93): courtesy of Aoi Kyoto Stay. **Konishi Gaffney House** (pages 198–205): courtesy of Konishi Gaffney, photographers Keiran Gaffney (page 205 center right) and Alan Craigie (all other photos pages 198–205, 232–3 near left). **Mjölk House** (pages 206–11): courtesy of Studio Junction. **Summer Retreat Sævik** (pages 212–21): courtesy of Irene Sævik and photographer Ivan Brodey www.ivanbrodey.com (pages 212–19) and photographer Massimo Leardini www.leardini.com (pages 220–1). **A1 House** (pages 18, 197, 222–31, 232 far left, 233 right, 234–5): courtesy of A1 Architects, photographer David Maštálka. **Page 79 top right**: courtesy of Nezu Museum ©Fujitsuka Mitsumasa. **Page 168**: courtesy of Muji House. **Pages 22, 82, 140, 170, 196** (textured background) © sigur/Shutterstock.com; **Pages 11** © Eric Marechal/Dreamstime.com; **12** © stevegeer/istockphoto.com; **79 top left** © ByeByeTokyo/ istockphoto.com; **81 top right** © mname/Shutterstock.com; **81 bottom left** © Chiharu/ Shutterstock.com; **137 top left** © Brendan Delany/istockphoto.com; **137 top right** © Sam DCruz/Shutterstock.com; **137 bottom left** © Sam DCruz/Shutterstock.com; **137 bottom right** © Sam DCruz/Shutterstock.com; **139 top right** © Sam DCruz/ Shutterstock.com; **139 bottom left** © cowardlion/Shutterstock.com; **139 bottom right** © CHEN WS/Shutterstock.com; **194 above** © Greir11/Dreamstime.com; **194 below** © Lalan33/Dreamstime.com; **195** © Mariusz Prusaczyk/Dreamstime.com

ACKNOWLEDGMENTS

I would like to give my sincere thanks to all who helped in the completion of this book. There were many architects, designers and photographers who shared their work, stories and ideas. Many went beyond the call of duty.

Miwa Mori of Key Architects accompanied me to see her Passive House in Karuizawa (my thanks to the owner as well), while Kazuyuki Igawa came from Chiba to Tokyo to spend a few hours describing his recent house renovation and the importance of saving traditional houses for modern families. Edward Suzuki was first on board with his thoughtful Katsura-inspired project, and in Kyoto Moritz Kruger was an enthusiastic and helpful source of information on Aoi Kyoto Stay's *machiya* restorations. Mariko Inaba of Kengo Kuma and Associates spent much effort in finding the right images, and in Norway Irene Sævik and Ivan Brodley kindly responded to a roundabout request. Lenka Kremenova of A1 Architects provided thoughtful insights into what Japanese aesthetics have to say to Bohemia. Jim Lambiasi has been incredibly supportive of the project from its beginning and helped with the invaluable assistance of Joshua Ito, who kindly redrew many of our architectural plans.

To all those at Tuttle Publishing who helped see this book through to completion, thank you so much for your hard work, patience and professionalism.

Most of all, I would like to thank Dr Geeta Mehta without whom my life in Japan would have been very different. She introduced me to the world of Japanese architecture, sharing her time, knowledge and clear ethical perspective on the built environment. Without her amazing generosity, this book would not have been written.